THE ORIGINAL PRINT

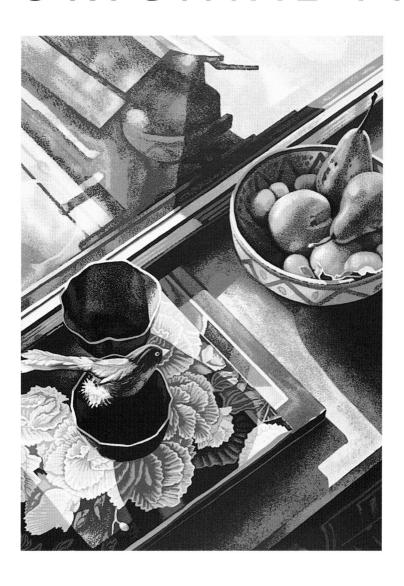

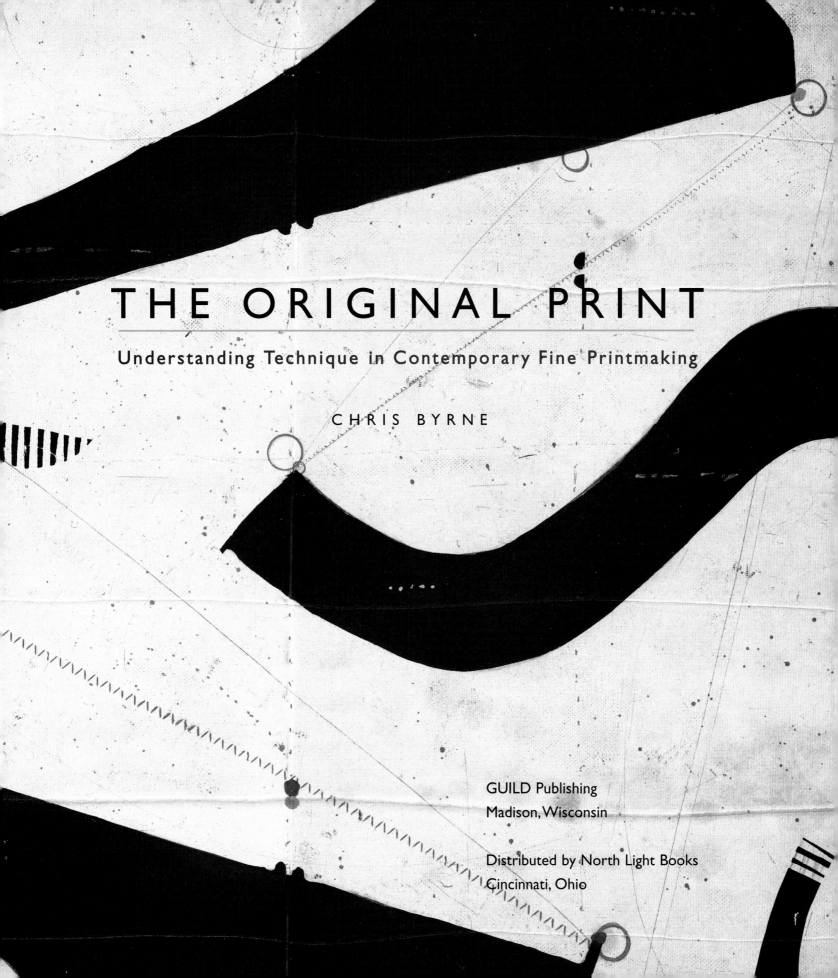

THE ORIGINAL PRINT

Understanding Technique in Contemporary Fine Printmaking

CHRIS BYRNE

GUILD Publishing
Madison, Wisconsin

Distributed by North Light Books
Cincinnati, Ohio

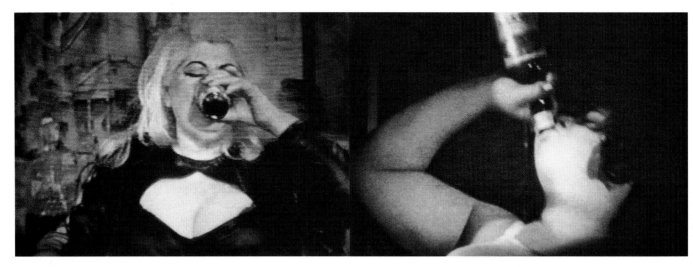

Photo by William Lytch

THE ORIGINAL PRINT

Understanding Technique in Contemporary Fine Printmaking

Chris Byrne

Published by GUILD Publishing, an imprint of GUILD, LLC
931 E. Main Street, Madison, Wisconsin 53703
TEL 608-257-2590 FAX 608-257-2690

Art Director: Georgene Pomplun
Chief Editorial Officer: Katie Kazan
Project Editor: Jill Schaefer

Distributed by North Light Books, an imprint of F&W Publications, Inc.
4700 East Galbraith Road, Cincinnati, OH 45236 TEL 800-289-0963

08 07 06 05 04 03 02 7 6 5 4 3 2 1

ISBN: 1-893164-14-4
Printed in China

Copyright © 2002 Chris Byrne

Pages 2-3: Caio Fonseca, *Seven String Etching No. 1* (detail), 2001, color spit-bite aquatint with soft-ground etching and chine collé, 38 x 48 1/2 inches, edition: 50, publisher: Paulson Press, photograph: M. Lee Fatherree. See page 58.

Above: John Waters, *Drunk,* 1998, photogravure, 11 1/4 x 20 inches, edition: 40, publisher: Graphicstudio/University of South Florida, photograph: William Lytch.

"*Drunk* is a historic print, the first to solve plate-registration problems in the production of hand-printed, multiplate color photogravure. Printer Deli Sacilotto made a plate for each of the six colors used and manipulated the colors to obtain the saturation and density of color characteristic of video. Cult film director John Waters photographed his stars Divine (from *Pink Flamingos*) and Edith Massey (from *Female Trouble*) directly from his movies as they played on the video screen. The video lines are visible in the final print."

– Noel Smith, publications coordinator, Graphicstudio/University of South Florida

TABLE OF CONTENTS

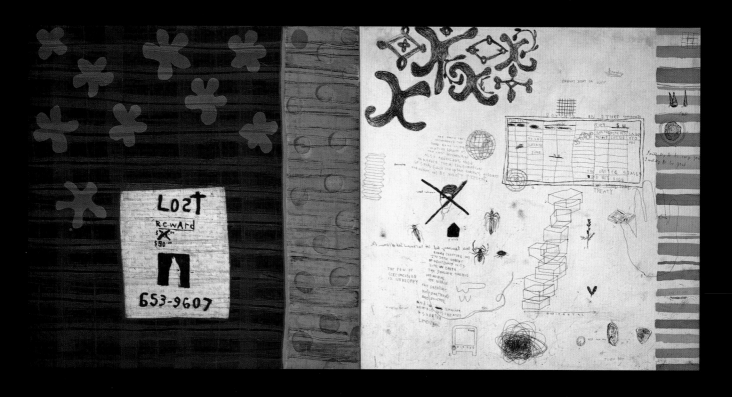

THE ORIGINAL PRINT

An original fine art print is the creation of a work of art, by an artist, in the print medium. What distinguishes it from printed reproductions is the artist's direct participation in the creation of the image. It differs dramatically from a poster, which is a mechanical reproduction of an original work of art. Although there are examples of posters that can be considered works of art because of the artist's involvement in the reproduction process, most posters are executed without the participation of the artist, or even produced posthumously. This will never be the case with original prints. They are new works created by the artist and, for that reason, they are considered within the larger body of the artist's work.

— Chris Byrne

ARTIST: Squeak Carnwath
TITLE: Every Creature Found
DATE: 1999
MEDIUM: Hard-ground and soft-ground color etching, sugar-lift and soap-ground aquatint
PAPER SIZE: 34$^1/_2$ x 61$^1/_2$ inches
EDITION: 30
PUBLISHER: Paulson Press

PREFACE

Printmaking in the United States has enjoyed a tremendous resurgence in the last half of the twentieth century. Many printmaking studios and publishing houses were founded, including Brook Alexander Editions, Crown Point Press, Gemini GEL, Graphicstudio/University of South Florida, Landfall Press, Marlborough Graphics, Pace Prints, Paulson Press, Riverhouse Editions, Edition Schellmann, Shark's Ink, Stewart & Stewart, Solo Impression, Inc., Tamarind Institute, Universal Limited Art Editions, Inc. and Diane Villani Editions. Some of these studios promote a certain type of printmaking, such as etching or lithography. Others are affiliated with major galleries, while still others are not-for-profit corporations with an educational mission. It is clear, however, that all have promoted the appreciation of fine art prints and printmaking.

Tandem Press was founded in 1987 as a self-supporting workshop at the University of Wisconsin-Madison. From the beginning, our goal has been to bring internationally recognized artists to the press to interact with students, faculty and the community, and to parallel the overall University of Wisconsin-Madison mission of education, research and public service.

At a printmaking studio, one is privileged to observe and experience the creative process that each artist brings to his or her work. This is in contrast to the other visual arts. One has the opportunity to see a musician play, a soprano sing, a dancer move expressively across the stage or actors interpret the work of playwrights. But, like writers, visual artists work in solitude. We see the finished works, but we rarely witness the creation. At printmaking studios across the country, the excitement of the creative process is palpable when an artist is in residence.

Printmaking is a collaborative process. At Tandem Press and at other printmaking studios, master printers provide the technical expertise to enable the artist to create an etching, a woodblock, a lithograph or a silkscreen. At the same time, they facilitate the process that brings the artists' creative ideas to fruition.

At a print studio, one also sees how the experience of printmaking influences the artist's painting and sculpture, and vise versa. David Lynch, the internationally renowned filmmaker, has described his painting as a process of discovery of action and reaction. Lynch described his feelings about the process of print-making during a talk in Madison: "It has the same sort of excitement as when you go to the photo shop to get your pictures back," he said. "Even though you took them, they never come out exactly the way you see them through the camera. There is always a surprise, and that's the way it is with printmaking. With action and reaction, exciting things begin to happen."

Many prints arise out of the artist's concerns in painting and sculpture. For example, in 1999, Judy Pfaff created an immense public sculpture for the ODS Tower in Portland, Oregon. The sculpture rises almost sixty feet and incorpo-rates a Western red cedar tree, supported by a steel truss and stainless steel tieback, along with cast bronze and acrylic elements. Shortly afterwards, she came to Tandem Press, where she created a dramatic new body of work reflecting her interest in, and awe of, the Pacific Northwest.

Printmaking studios could be described as living visual arts museums. Members of the public have the opportunity to see nationally recognized artists at work. These studios are all extraordinary, creative and exciting places for the seasoned and budding collector alike, and many of these studios offer tours and work-shops on a regular basis.

Finally, printmaking is a wonderfully democratic art form. Because prints are created in multiples, a given image will be selected by a number of collectors. This has the result of making an artist's image better known. In turn, particular images take on a life of their own in the history of art and become even more famous because they are multiples. This book offers a wonderful introduction to the field of printmaking and will lead the collector to a lifetime of discovery and learning.

Paula McCarthy Panczenko
Director, Tandem Press

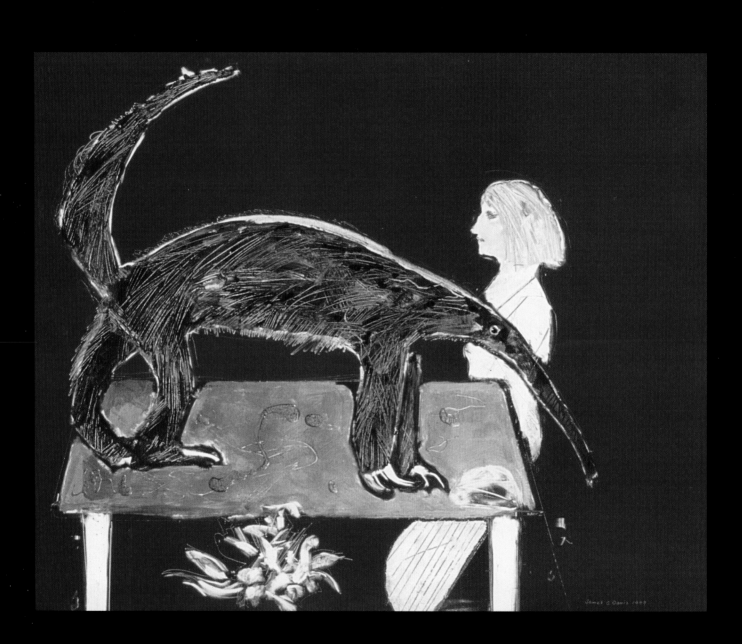

AN OVERVIEW
PRINTMAKING HISTORY & TECHNIQUES

This book is for artists and art lovers who appreciate fine art prints and want to learn more about the basic methods of printmaking. As an art dealer, I've watched artists create fine art prints and learned to understand the process, from the artist's initial concept to the completed print. I've also seen how often an image must be interpreted and reinterpreted before its final realization. And although it is not always necessary for an artist to work with a master printer (many artists create and produce their prints independently), it's often the strength of this collaboration that is most evident in the finished print.

During one of my first experiences observing the printmaking process, I visited the artist Richmond Burton as he began to develop an image as a print. David Fraze, a dedicated and knowledgeable collector who already owned important examples of Richmond's paintings, drawings and prints, accompanied me. David had inherited his love of prints from his parents; when he was a boy, living in the Texas panhandle, he told me, "a traveling print dealer would stop by our house. He'd pull a large portfolio of prints from the trunk of his car. This portfolio included works by Pablo Picasso, Marc Chagall, Georges Rouault, Joan Miró, Marcel Duchamp and many other superb artists."

Although David had a long history with fine art prints by this time, he — like me — had never before watched the collaborative creation of a print by an artist and master printer. As we entered the print studio below Canal Street, in Manhattan, the master printer was making suggestions to Richmond about ways to achieve certain painterly effects in the prints. Often when a young artist begins to work in the printmaking medium, his visual vocabulary is dependent on his work in another medium; he is able to reference only his knowledge as a painter, for example, or as a sculptor. As the relationship grows stronger between the artist and master printer, and as they experiment with the artist's

ARTIST: James G. Davis
TITLE: Mary Anne and Anteater
DATE: 1999
MEDIUM: Monotype
PAPER SIZE: 26 x 33 inches
PUBLISHER: Segura Publishing Company

Photo by Harrison Evans

ARTIST: Richmond Burton
TITLE: Breathe (detail)
DATE: 1994
MEDIUM: Oil on canvas
PAPER SIZE: 96 x 120 inches

Richmond Burton works with oil paints as well as various print media; see his woodcut, aquatint and lithograph on pages 13 through 15. *Breathe* belongs to the collection of Mr. and Mrs. Bill Lenox of Dallas, Texas, and is on long-term loan to the Dallas Museum of Art.

vision in various printmaking techniques, they often achieve technical effects that are not reproducible in other media.

With this in mind, it was interesting to observe how, without dictating the outcome of the final image, the master printer was able to anticipate Richmond's vision and make suggestions accordingly. In a case like this, the master printer contributes more than simply his or her expertise in producing exact multiples for the edition.

As David and I reviewed some of the trial proofs, we talked about the relationship between Richmond's prints and his paintings. No less than the paintings, the prints were original works of art; they were simply executed in another medium. David had spent a lot of time with Richmond's paintings in his own collection. For this reason, he was very sensitive to the relationship between the paintings and the prints. Probably the most distinctive characteristic of the various methods used to create prints is that the artist does not apply ink directly to the paper. Instead, it is applied to a woodblock, plate, stone or screen and then printed onto the paper.

As Richmond's print progressed, David pointed to the subtle tactility of its surface. Surface texture is typically associated with drawings and paintings, where the artist applies marks directly. And although the tactility of the surface was something readily identifiable with Richmond's painting, it had been reinterpreted in the print medium through the assistance of the master printer. Many important artists employ printmaking techniques as a way of creating a greater vocabulary for art making; this vocabulary remains simultaneously autonomous and related to other art media.

Today, this print by Richmond Burton is included among the many important paintings and drawings in David Fraze's collection.

Beginning with engraved cave art, and through the invention of the printing press, printmaking was thought of as a medium of communication. The milestones in that evolution include the Sumerians introducing the duplication of engraved designs on cylinder seals (fourth century B.C.), the Chinese producing a simple form of print derived from rubbings (second century A.D.) and the Japanese making the first woodblock prints (ninth century A.D.). By the 1700s, artists began to produce limited editions and to sign their prints. In this way, the evolution of printmaking can be viewed as an evolution from basic communication to original work of art.

Because the various printmaking processes have intrinsic characteristics, each medium can be identified by a distinctive look. These techniques can be divided into four basic processes: relief, intaglio, lithography and screenprint.

• Relief printing is a process whereby areas are cut away, leaving the raised image to be printed. Included in this technique are woodcuts, wood engravings and linocuts.

• Intaglio processes, including aquatint, drypoint, engraving, etching, mezzotint and photogravure, employ the reverse approach: the images are incised or etched into the surface of metal plates.

• Lithography is a process in which the printed and non-printed areas lie on the same plane. The image is drawn on a smooth stone or plate and – in a way that is similar to the other processes – the print is created through direct pressure.

• Screenprint images (also referred to as serigraphs and silkscreens) are created as parts of the screen are blocked out so that ink prints only on selected areas of the paper.

Photo by James Dee

ARTIST: Richmond Burton
TITLE: Breathe (detail)
DATE: 1995
MEDIUM: Hand-printed woodblock
PAPER SIZE: 29¹/₂ x 39¹/₂ inches
EDITION: 35
PUBLISHER: Richmond Burton

This 26-color woodcut was made using eight woodblocks and five Mylar stencils. The print closely resembles Burton's painting, although it has been conceived and executed in a different medium.

Working together, the artist and master printer first create trial proofs, experimenting with inks and papers until they are satisfied with the image. The approved proof is signed as the "B.A.T." or *bon a tirer* (literally, "good to pull"). The *bon a tirer* becomes the standard for the edition; all subsequent impressions are printed to this standard.

Each print image that is part of the edition is signed and numbered by the artist. Once the edition is completed, the plate, woodblock or stencil is destroyed or discarded, ensuring that no other images will be made: thus a "limited" edition.

The numbering convention for prints involves two numbers placed one above the other, like a fraction. The bottom number indicates how many impressions exist in the edition; the top figure identifies the number, sequentially, of the specific impression. Proofs are not considered part of the edition of prints; they most often include not only trial proofs and the B.A.T., but also artist's proofs and printer's proofs; these first-quality proofs are designated "A.P." and "P.P." respectively. Fine art prints may also have what is called a dry stamp or "chop" — an impressed mark in the paper that identifies the printer. This is most often seen in images printed by a workshop, but some independent artists have their own chops or dry stamps. In instances where the artist chooses to create more than one print related by imagery, scale or theme, the group of prints is called a "series" or "suite."

Original prints are pulled by hand and should be thought of not as copies, but as original works existing in multiple impressions. Monoprints, with only one impression of each printed image, are the exception. In this case, there is no edition. In its simplest version, a monoprint requires only a surface with which to transfer the inked image to paper; for this reason, monoprints often appeal to artists who are just beginning to make prints or who wish to experiment freely.

Photo by James Dee

ARTIST: Richmond Burton
TITLE: Flesh/Valentine
DATE: 1996
MEDIUM: Spitbite aquatint with soft ground
IMAGE SIZE: 24 x 14½ inches
EDITION: 25
PUBLISHER: Richmond Burton

Prints allow art enthusiasts to collect original artworks. Because they are created in multiple impressions, prints are often more accessible and affordable than paintings or drawings. For the artist, printmaking processes become tools for expression; they often introduce new means of working or an expanded technical vocabulary that can be applied to other media. Successful prints can also show evidence of the unique collaborative relationship that exists between an artist and a master printer. In this relationship, the printmaker's participation expands beyond the execution of the prints to include joint experimentation with the artist.

AUTHOR'S NOTE

The following definitions apply to the captions found in this book.

DIMENSIONS: In almost every case, dimensions refer to the size of the paper on which the image is printed. Occasionally, the size of the image itself is listed; these instances are clearly labeled. Dimensions are given in inches, as height by width.

EDITION: This term refers to the total number of prints created from the original image. Each print is typically numbered and signed.

PUBLISHER: This term refers to the business or facility (print house) where the image was created and printed. Typically, visiting artists collaborate with a master printer who owns or works for the print house.

Photo by James Dee

ARTIST: Richmond Burton
TITLE: Love of the Blue Flame
DATE: 1996
MEDIUM: Lithograph
PAPER SIZE: 29¹/₄ x 21¹/₄ inches
EDITION: 40
PUBLISHER: Richmond Burton

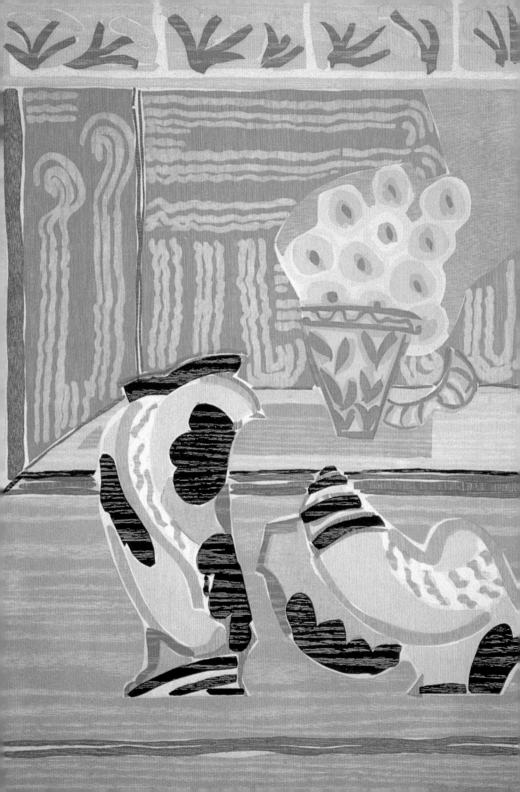

RELIEF

Relief printing is the most direct of the four basic techniques. This process includes woodcuts, wood engravings and linocuts — all simple to execute and inexpensive to produce. A printing press is unnecessary.

To produce a relief print, the artist first creates a drawing on a wood or linoleum block; the areas of the design that are not to print are cut away from the block's surface, leaving raised the image to be printed. After the relief surface is inked, paper is placed on top and pressure is applied to produce an impression.

The relief method is the oldest documented form of printmaking. The Chinese, who made printmaking possible through the invention of paper, used the woodcut technique to create religious images as early as the ninth century. This simple method was quickly adopted throughout the East and the West. By the 1400s, the medium's bold visual qualities had made it a popular art form in Europe. Woodcut prints were used to produce everything from religious illustrations to playing cards during this period.

In 1437, Johannes Gutenberg's experiments with movable type irrevocably connected woodcut illustrations with the printed word. This innovation caused woodcuts, when used as book illustrations, to be produced in series, and the book and the woodcut have coexisted in publications ever since.

German painter Albrecht Dürer (1471-1528) was the first important artist who understood not only this medium's potential for communication, but also its intrinsic aesthetic properties. The woodcut technique enabled his contributions as both an artist and an artisan to be recognized throughout Europe.

ARTIST: Betty Woodman
TITLE: Kabuki Space
DATE: 2000
MEDIUM: Color woodcut
PAPER SIZE: 37 x 25 inches
EDITION: 30
PUBLISHER: Shark's Ink

"We have collaborated with Betty regularly since 1985. Our first projects were monotypes and monotype collages. In 1992, we began making woodcuts, and since then we have done eight editions. Betty's fresh and inventive approach to printmaking echoes her work in clay. She typically prepares a color study before coming to the studio. We then determine how the blocks will be cut and select specific woods for the texture and direction of their grain. *Kabuki Space* was printed from nine woodblocks on Natural Thai Mulberry paper in 15 colors of lithographic ink."

— Bud Shark, director and master printer, Shark's Ink

It was in Japan, however, during the *Ukiyo-e* period (circa 1750), that the greatest technical and aesthetic advances for woodcut printmaking were achieved. Among the many innovations at this time was the use of wild cherry wood. Hard and fine-grained, it allowed intricate cutting to be done either with or against the grain, thus creating a particularly fluid and refined line. The discovery and influence of these advances in Europe quickly transformed the work of many prominent nineteenth-century artists, especially Paul Gauguin and Vincent van Gogh. Gauguin combined exotic subject matter with Japanese iconography to create his color woodcuts.

By the early twentieth century, a revival of woodcut print-making took place among the artists known as the expressionists. Led by the Norwegian Edvard Munch, this group adapted the flattened compositions of Japanese prints to create vital personal imagery. The directness of these artists' methods, yielding jagged linear effects and bold patterns, has become identified with the woodcut's pictorial vocabulary in the West.

The most obvious visual characteristic of the woodcut print is the inclusion of a wood-grain texture. Using chisels, cutting knives and gouges, the artist cuts the woodblock on the planked side. The direction and texture of the grain is an important consideration to the artist, as it becomes integrated into the final design generated when the block is cut. Wood type also affects the printed image: with certain varieties, such as pine, the grain will be pronounced. The woodcut technique also makes possible interesting variations between clean and ragged lines, simple and complex shapes, and bold and intricate patterns. Color can be added by hand or through the use of a stencil.

During the nineteenth century, the process of wood engraving became popular for reproducing preexisting images. A wood engraving is different from a woodcut in that the cutting is done on the end grain of the wood. End

Photo by Shark's Ink

ARTIST: John Buck
TITLE: Heart Mountain Wyoming (detail)
DATE: 2000
MEDIUM: Color woodcut
PAPER SIZE: 62 x 37 inches
EDITION: 15
PUBLISHER: Shark's Ink

grain has a denser texture than plank grain and therefore does not become an intrinsic component of the design. Instead, the engraving is made up entirely of the engraver's incisions.

Wood engravings are typically cut with "gravers" corresponding to various line widths. The engraving process is precise and controlled; for this reason, the images are usually subtle, small-scale compositions in black and white. Wood-engraved images are often too detailed to allow the use of color overprinting; monochromatic printing makes the best use of the technique's refined graphic effects.

Linocut (linoleum) prints produce vibrant graphic images and incorporate both shapes and patterns. Linoleum is a composite material made of cork and rosin, with a burlap backing; for printmaking, it is usually mounted on wood. The "lino block" can be cut in all directions with knives to create a linear effect, or with gouges to cover larger simplified areas. To print, a soft roller is used to ensure that the ink covers the block evenly.

Pablo Picasso almost single-handedly transformed linocut printmaking from the level of grade-school art project to a powerful contemporary medium. He perfected the "reduction-block" method for both linocuts and woodcuts, creating images by cutting into the block before printing each new color. The process dictates that the final image be conceived in reverse, as the block is systematically reduced to achieve the final print image.

Relief printing offers the artist an impressive visual vocabulary. Because of its simplicity, this method can be combined with other techniques to create surprising and dynamic compositions. With easily found, inexpensive materials, the artist can use relief printing to create impressions as varied as the detached formality of Japanese design or the raw immediacy of German expressionist imagery.

Photo by Jim Wildeman

ARTIST: Gronk
TITLE: Bullet in the Back (detail)
DATE: 1995
MEDIUM: Linoleum cut
PAPER SIZE: 35 3/4 x 27 3/4 inches
EDITION: 30
PUBLISHER: Tandem Press

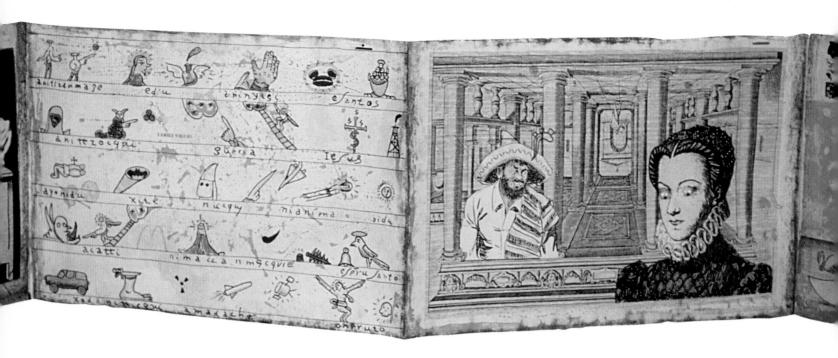

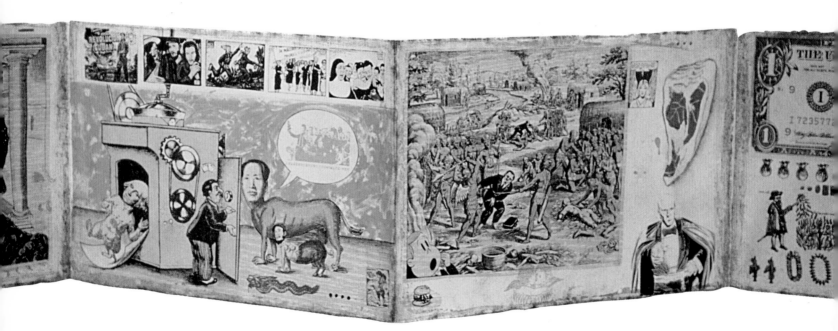

ARTIST: Enrique Chagoya

TITLE: utopiancannibal.org (details)

DATE: 2000

MEDIUM: Lithograph, woodcut, chine collé and collage

PAPER SIZE: 7¹/₂ x 92 inches

EDITION: 30

PUBLISHER: Shark's Ink

"Utopiancannibal.org is the third codex we've done with Enrique Chagoya. These prints are complicated to produce and involve lithography, woodcut, chine collé and collage. They are based upon surviving Mayan codices. The Amate paper gives the print an aged look and is still made the traditional way by the Otomi Indians of Mexico."

— Bud Shark, director and master printer, Shark's Ink

ARTIST: Nancy Mladenoff

TITLE: Cityscape

DATE: 1998

MEDIUM: Wood relief and lithography

PAPER SIZE: 28^1/$_2$ x 29 inches

EDITION: 30

PUBLISHER: Tandem Press

"Nancy Mladenoff's images question the representation of young girls in various roles. *Cityscape* was created using a combination of lithography and wood relief. The wood relief was cut with a scroll saw so that all of the pieces fit together like a puzzle. Each wooden piece was inked in a specific color, then all of the parts were reassembled and printed in one run through the press. Once the printing of the wood relief was complete, the lithograph was printed on top."

– Paula McCarthy Panczenko, director, Tandem Press

Photo by Shark's Ink

ARTIST: Hiroki Morinoue
TITLE: Edge of the Pond
DATE: 2000
MEDIUM: Color woodcut and lithograph
PAPER SIZE: 26 x 56 inches
EDITION: 30
PUBLISHER: Shark's Ink

"Hiroki Morinoue studied traditional Japanese woodblock printing in Japan. In *Edge of the Pond,* he has incorporated an antique Japanese kimono stencil on the print's end panels. The stencil was transferred to a litho plate and printed over the magenta woodgrain. The central panels illustrate Morinoue's skill in cutting the intricate woodblocks and overlaying the colored inks and woodgrain. He builds a rich, fabric-like weave of texture. This image was printed on White Thai Mulberry paper in eight colors from five woodblocks and one litho plate."

— Bud Shark, director and master printer, Shark's Ink

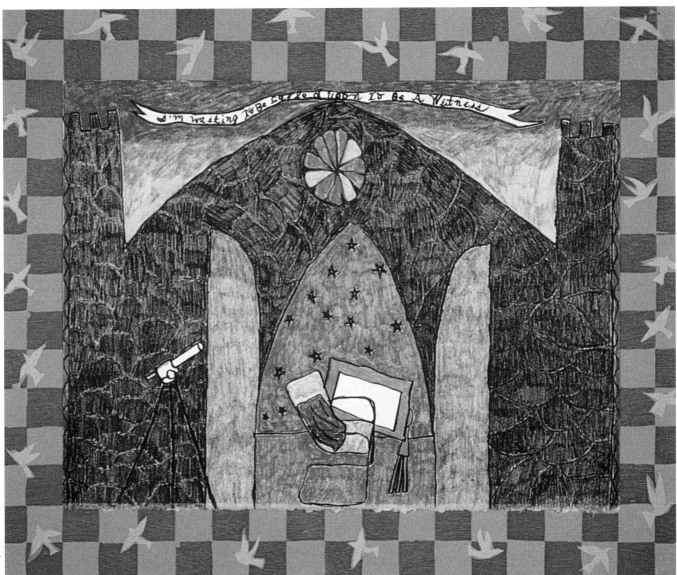

Photo by Shark's Ink

ARTIST: Hollis Sigler

TITLE: I'm Waiting to Be Called Upon to Be a Witness

DATE: 2000

MEDIUM: Color lithograph with woodcut and chine collé

PAPER SIZE: 15¹/₈ x 19¹/₈ inches

EDITION: 42

PUBLISHER: Shark's Ink

"*I'm Waiting to Be Called Upon to Be a Witness* is one of four prints that comprise Sigler's *Suite for the Gods*. The suite had to be completed through the mail; Hollis was too ill to travel due to her battle with breast cancer. The suite deals with her deteriorating condition and her impending death. It was very difficult to work on these prints knowing of her condition. But Hollis' desire and determination to keep working gave everyone who knew her tremendous respect for her inner strength and the way she lived her life. *I'm Waiting to Be Called Upon to Be a Witness* was printed in 14 colors from nine litho plates and two woodblocks. The plates were made from Mylars drawn by the artist. I cut the woodblocks."

— Bud Shark, director and master printer, Shark's Ink

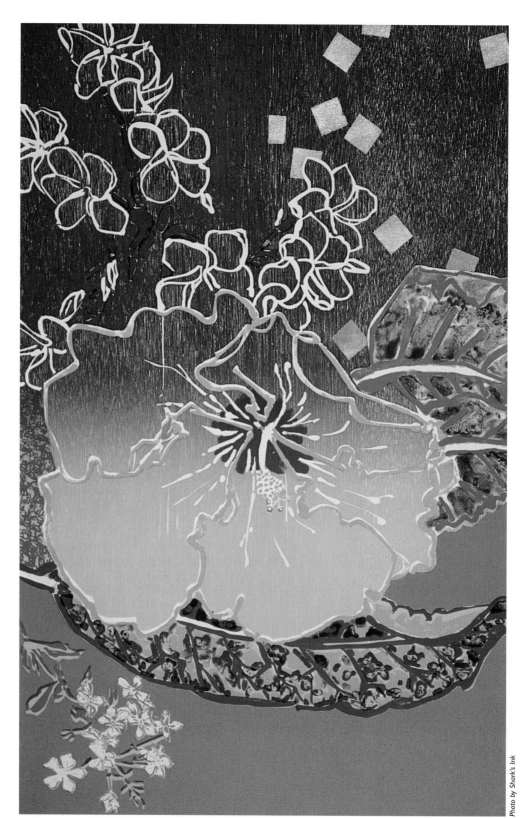

ARTIST: Robert Kushner
TITLE: Afterglow II
DATE: 1995–2000
MEDIUM: Lithograph with woodcut
and metal leaf
PAPER SIZE: 40 x 26 inches
EDITION: 30
PUBLISHER: Shark's Ink

"*Afterglow II* very effectively combines the
textures of lithographic washes and the
grain of a woodblock. The woodblock has
been printed in a color gradation (or "split-
fount inking") from magenta to yellow; the
inks were blended together on a large
roller and then rolled across the surface of
the woodblock. The washes were printed
from two lithographic plates, which were
hand-drawn by the artist using copier toner.
Three plates made from Mylars were also
hand-drawn by the artist using copier toner,
and one plate was made using gum arabic
stop-out. The Mylars were each direct-
transferred to positive plates. Composition
gold leaf squares were applied to the image
after printing."

— Bud Shark, director and
master printer, Shark's Ink

Photo by Shark's Ink

Photos by Shark's Ink

ARTIST: John Buck	*Left*	*Right*
MEDIUM: Color woodcut	TITLE: Crystal Lake	TITLE: Argosy
EDITION: 15	DATE: 2001	DATE: 1999
PUBLISHER: Shark's Ink	PAPER SIZE: 62 x 37 inches	PAPER SIZE: 62½ x 37 inches

"John Buck has an unusual approach to making woodcuts, creating the woodblocks like giant wooden puzzles. The pieces are lifted out and inked in various colors, then reassembled and printed simultaneously. Also unique is his method of incising the characteristic signs, symbols and images, which surround the central figure. The incising is done with a ballpoint pen, nail or other sharp tool. These lines create a background of complex sociopolitical images, which are juxtaposed and precariously balanced on top of each other. These incised images invite a wide range of interpretation by the viewer."

– Bud Shark, director and master printer, Shark's Ink

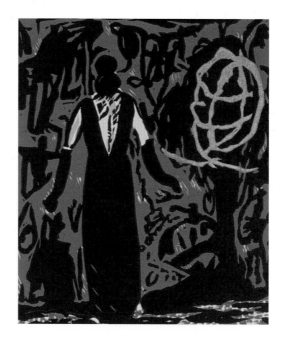
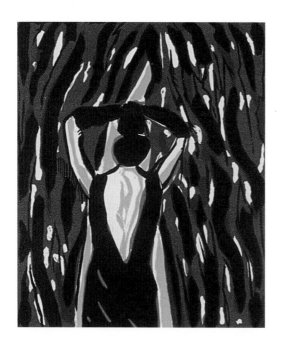
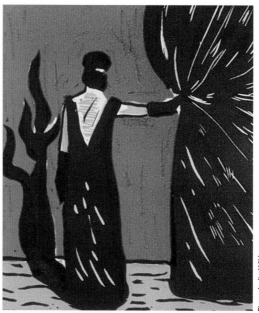

Photos by Jim Wildeman

ARTIST: Gronk
TITLE: Tormenta Suite in 12 Movements (III, IV, VI and XI)
DATE: 2001
MEDIUM: Linoleum cut
PAPER SIZE: 15½ x 14 inches (each)
EDITION: 75
PUBLISHER: Tandem Press

"In his *Tormenta Suite,* Gronk depicts 12 images of *La Tormenta,* a solitary figure with her back to the viewer. A reoccurring theme in Gronk's work, this metaphoric figure is ambiguous, sometimes comical and sometimes tragic. In this series of 12 linoleum cuts, approximately four blocks were used to create each image. The artist created 12 drawings and the master printers interpreted his brush marks in their cutting techniques."

– Paula McCarthy Panczenko, director, Tandem Press

Photo by Jim Wildeman

ARTIST: Gronk
TITLE: Bullet in the Back
DATE: 1995
MEDIUM: Linoleum cut
PAPER SIZE: 35$^{3}/_{4}$ x 27$^{3}/_{4}$
inches
EDITION: 30
PUBLISHER: Tandem Press

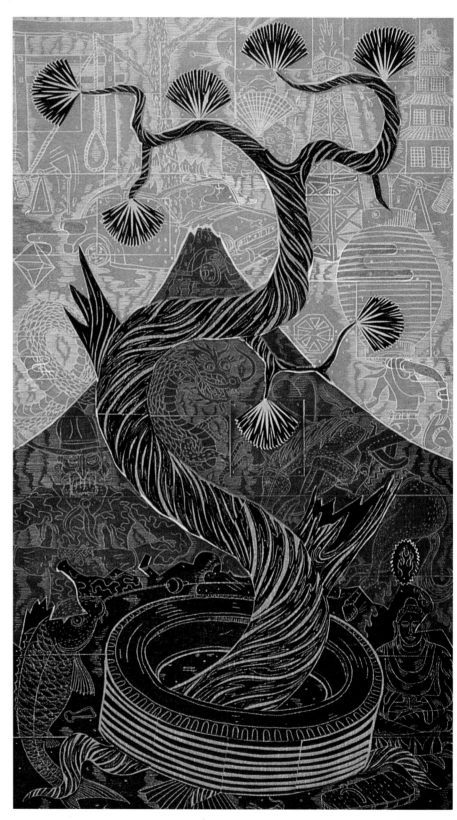

ARTIST: John Buck
TITLE: Heart Mountain Wyoming
DATE: 2000
MEDIUM: Color woodcut
PAPER SIZE: 62 x 37 inches
EDITION: 15
PUBLISHER: Shark's Ink

Photo by Shark's Ink

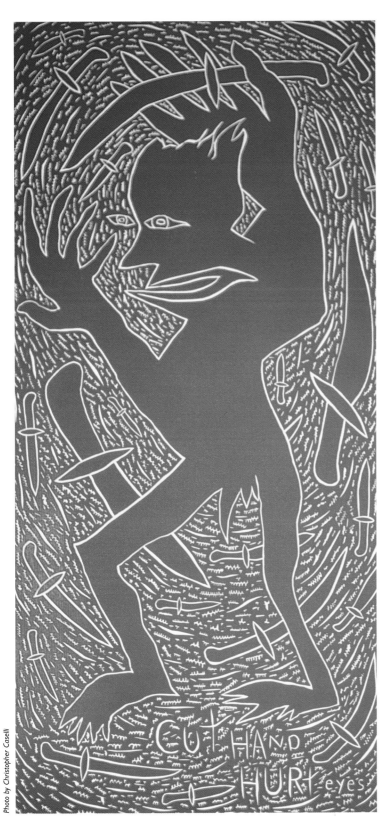

Photo by Christopher Caselli

ARTIST: James Surls
TITLE: Cut Hand, Hurt Eye
DATE: 1999
MEDIUM: Woodcut
PAPER SIZE: 70 x 35 inches
EDITION: 15
PUBLISHER: Flatbed Press

"Surls carved this relief image into cabinet-grade birch plywood. The woodcut block was too large to print on most large Asian paper sheets, and Surls wanted the paper to be buff-colored. As a result, we printed the edition on Arches Cover Buff, cut from a roll, using modified lithographic inks."

— Katherine Brimberry, co-director and master printer, Flatbed Press

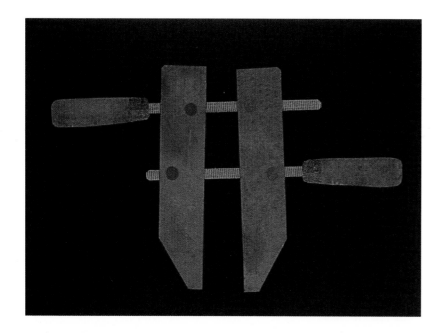

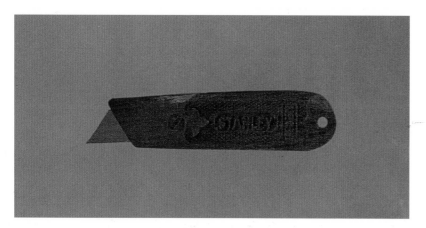

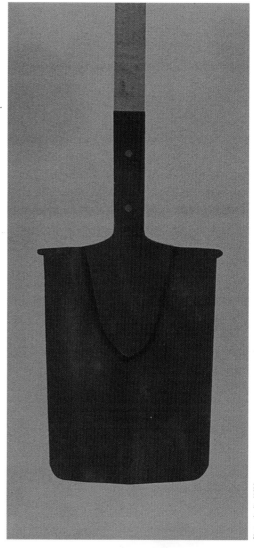

Photos by Jim Wildeman

ARTIST: Sam Richardson
DATE: 2001
PUBLISHER: Tandem Press

Above left
TITLE: Press Clamp
MEDIUM: Relief and collage
PAPER SIZE: 18 3/8 x 23 inches
EDITION: 12

Below left
TITLE: Sam's Mat Knife
MEDIUM: Relief, collage and pencil
PAPER SIZE: 11 x 16 inches
EDITION: 12

Above right
TITLE: A's Shovel
MEDIUM: Relief and collage
PAPER SIZE: 28 3/4 x 16 1/2 inches
EDITION: 8

Facing page
TITLE: Ken's Plane
MEDIUM: Relief, collage and pencil
PAPER SIZE: 16 x 25 inches
EDITION: 12

"West Coast artist Sam Richardson's editions are unique in that many of the parts are printed separately and then assembled using the chine collé process (collage). In several pieces from his recent tool series, Richardson used a two-step archival process where the paper is treated with a red iron oxide and uric acid, creating a rusted patina."

– Paula McCarthy Panczenko, director, Tandem Press

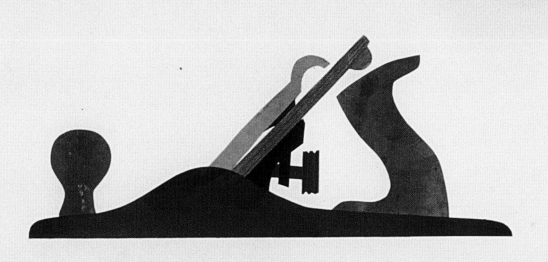

INTAGLIO

Unlike the other basic printmaking techniques, intaglio requires that the artist's drawing be incised into a metal plate, leaving the image to be printed recessed below the surface; the term "intaglio" refers to both the process and the recessed design. Intaglio techniques use sharp tools and acid-etch procedures to create lines and tonal effects. A number of processes involve intaglio, including aquatint, drypoint, engraving, etching, mezzotint and photogravure — and many prints are a combination of these techniques.

All intaglio plates are printed in the same basic way. The incised plate is filled with ink, after which the surface is wiped clean. Dampened paper is then positioned on top of the plate. Under pressure from the press, the paper is forced into the intaglio, where it picks up ink from the recessed areas and lines. The paper needs to be of extremely high quality because as it is pressed, an embossed effect is created. For intaglio printmaking, a heavy studio press (called a flatbed press) is used. After felt blankets have been placed over the plate to ensure even pressure, the intaglio passes between the press's two large rollers. However subtle the mark-making, this procedure produces a consistent image for each impression.

Although craftsmen used the technique of engraving to decorate bronze, gold and silver for thousands of years, the intaglio printmaking process was not developed until the 1400s, when paper became readily available in Europe. During the Renaissance, the engraving technique was adopted for printmaking by Florentine artists; in northern Europe, German artists first used the medium to create reproductions of preexisting images — paintings, maps and book illustrations. During the late fifteenth and early sixteenth centuries, Albrecht Dürer, who began his career as a goldsmith, emerged as one of the first masters of both engraving and drypoint techniques. However, it wasn't until the seventeenth century that the full expressive range of the etching medium was revealed through

ARTIST: Greg Colson
TITLE: "How to Look Your Best" Survey
DATE: 2000
MEDIUM: Color spit bite with sugar-lift and soft-ground etching
PAPER SIZE: 25¹/₂ x 22 inches
EDITION: 35
PUBLISHER: Paulson Press

the explorations of Rembrandt van Rijn. By the end of his life, Rembrandt had created more than three hundred etchings and drypoints; many were portraits, while others depicted biblical allegories.

During the eighteenth century, British artist William Hogarth reproduced his paintings as copyrighted engravings in order to make his moralizing satires accessible to a larger audience. At about the same time, the poet William Blake invented a unique and mysterious intaglio process to create visionary narratives. Early in the nineteenth century, in Spain, Francisco de Goya produced technically sophisticated and politically devastating etchings and aquatints, among them the well-known *Desastres de la Guerra* (Disasters of War).

Artists as diverse as James Ensor (Belgium), Pierre-Auguste Renoir (France) and Mary Cassatt (United States) experimented with intalgio during the second half of the nineteenth century, integrating non-Western imagery into their pictorial vocabularies. Early-twentieth-century masters using intaglio techniques included Henri Matisse, Max Ernst, Joan Miró and Pablo Picasso. Following World War II, the artists Chuck Close, Jasper Johns, Richard Diebenkorn and Wayne Thiebaud contributed to a revival in intaglio techniques.

ARTIST: Trenton Doyle Hancock
DATE: 1999
MEDIUM: Copper plate line etching and aquatint with spit bite
EDITION: 16
PUBLISHER: Flatbed Press

This page
TITLE: Post Load
IMAGE SIZE: 10 x 8 inches

Facing page
TITLE: Happy Shtick
IMAGE SIZE: 4 x 4⁷/₈ inches

"Hancock used traditional line-etching techniques on copper to create the linear areas of this image. He then added a fluid tonality with a technique called 'spit bite.' This technique involves applying acid mixed with a buffer solution of gum arabic directly onto the aquatinted plate."
— Katherine Brimberry, co-director and master printer, Flatbed Press

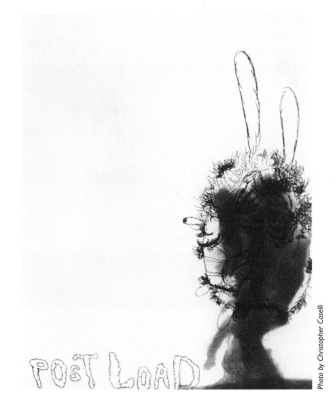

Photo by Christopher Caselli

Many contemporary artists consider intaglio, with its various techniques, the most versatile of all printmaking media. And although the procedures are easy to learn, the variables of each method can make it difficult to master, requiring a patient and experimental disposition on the part of both artist and printmaker.

Beyond simple line etching, two families of intaglio techniques result in very different effects. With etching, aquatint and photogravure, the images are produced by using acid to corrode the copper plate. For the techniques of engraving, drypoint and mezzotint, images are created directly by incising the metal plate with sharp tools; no acid-resistant grounds are used.

ETCHING

An etching is most often produced with a copper plate, although plates made of brass, steel and zinc can also be used. An acid-resistant ground (either hard or soft) is applied to the heated plate with a roller until an even cover is achieved. Next, the artist uses an etching needle to inscribe a drawing. When the plate is placed in an acid bath, the exposed areas become etched; effects vary depending on the length of exposure. The ground allows the acid bath to bite into the artist's inscribed drawing without altering the remaining areas of the plate.

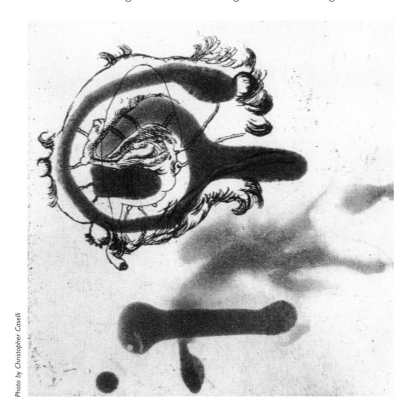

Photo by Christopher Caselli

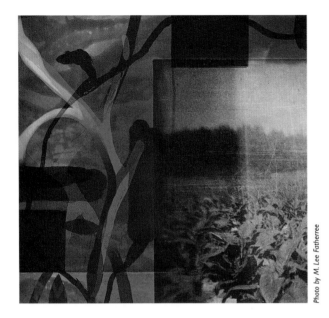

Photo by M. Lee Fatherree

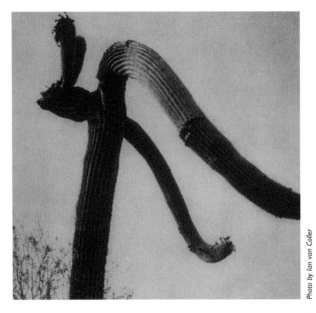

Photo by Ian van Coller

A stop-out varnish can be used to block areas, thereby creating greater tonal ranges.

The simplest way to execute a color etching is by introducing different colored inks to various areas of the plate. Alternately, the plate may be cut in pieces in order to ink each color separately; the image is then reassembled before it is printed. Other color methods may involve the use of additional plates.

AQUATINT

For the aquatint process, which is often used with line etching to create tonal variations, powdered resin is applied to the heated plate to produce a fine-grained surface. When the plate is placed in the acid bath and the image is etched, a pitted texture is created that will retain a layer of ink.

PHOTOGRAVURE

Photogravure is an etching technique that produces photographs printed from a copper plate on a press. The photographic image is fixed on the copper plate using a gelatin relief tissue and an aquatint ground that allows the acid to bite thousands of tiny depressions on the plate at varying depths and dimensions to achieve a continuous tone image characteristic of photography.

ENGRAVING

Engraving, which involves direct engraving of the metal plate, is the oldest of the intaglio techniques and uses instruments with shaped tips, called burins, to cut into the plate. The linear effects of engraving are sharper and more distinct than those produced through the etching processes.

Above
ARTIST: Radcliffe Bailey
TITLE: Tobacco Blues (detail)
DATE: 2000
MEDIUM: Color aquatint etching
with photogravure and chine collé
PAPER SIZE: 50 x 40 inches
EDITION: 30
PUBLISHER: Paulson Press

Below
ARTIST: Mark Klett
TITLE: No. 43 (detail)
DATE: 1997
MEDIUM: Photogravure
PAPER SIZE: 24 x 19 inches
EDITION: 40
PUBLISHER: Segura Publishing Company
Image © 1997 by Mark Klett

DRYPOINT

Drypoint is intaglio's most direct method; only the simple act of drawing with a sharply pointed tool is required. As the plate is scored, a metal ridge, called the burr, develops on the side of each mark. When printed, the burr holds more ink and gives the image a richer quality. Because the burr wears down quickly during printing, this technique can produce only small editions.

MEZZOTINT

For the mezzotint process, a tool called a rocker is used to roughen the entire plate in several different directions. If the plate were to be printed at this point, it would be a dense black. The artist uses scrapers and burnishers to develop areas of the plate, composing the image from dark to light. The resulting composition will have atmospheric tones much like a photograph.

COLLOGRAPH

Collograph prints use materials as varied as glue, gesso and found objects to create a collage block. The block is inked, wiped to leave ink only in the recessed areas, and printed, often creating an embossment in the paper.

Since the Renaissance, intaglio has held a position of prestige among makers and admirers of fine art prints. For the contemporary artist, intaglio offers many possibilities for exploring and combining different techniques in the same print. The precise nature of the etched or engraved line, the richness and tactility of the printed surface, and the variety of materials and techniques that can be used all combine to make it a remarkably versatile and expressive area of printmaking.

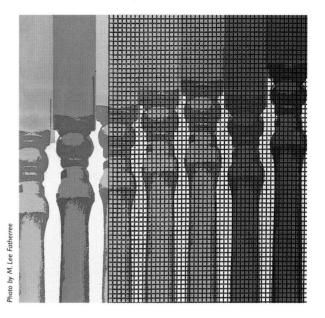

Photo by M. Lee Fatherree

Photo by M. Lee Fatherree

Above
ARTIST: Deborah Oropallo
TITLE: Post Rank (detail)
DATE: 1999
MEDIUM: Color aquatint etching with soft-ground etching
PAPER SIZE: 46 x 36 inches
EDITION: 35
PUBLISHER: Paulson Press

Below
ARTIST: Greg Colson
TITLE: "How to Look Your Best" Survey (detail)
DATE: 2000
MEDIUM: Color spit bite with sugar-lift and soft-ground etching
PAPER SIZE: 25¹/₂ x 22 inches
EDITION: 35
PUBLISHER: Paulson Press

Photo by M. Lee Fatherree

ARTIST: Christopher Brown
TITLE: Half Step
DATE: 1997
MEDIUM: Color soft-ground and aquatint etching
PAPER SIZE: 19 x 20 inches
EDITION: 50
PUBLISHER: Paulson Press

Photos by Christopher Caselli

ARTIST: James Surls
DATE: 1999
MEDIUM: Soft-ground etching/double sided
PAPER SIZE: 12 x 12 inches (each)
EDITION: 22
PUBLISHER: Flatbed Press

Clockwise from
upper left
TITLE: Faces
TITLE: Shirt
TITLE: Hands
TITLE: Giver

"Soft-ground etching allows an artist to create a crayon-like line by using a sticky, waxy ground on a copper plate. For *Faces*, Surls placed a sheet of paper over the grounded plate and drew on the paper with a hard, wide-leaded pencil. The paper, having stuck to the ground where he made marks, pulled the ground off the plate as the paper was removed, leaving open areas to etch. *Shirt* has been printed on both sides. An application of very thin rosin varnish made the paper transparent, allowing the viewer to see both the front and mirror images, thereby creating a new, melded image."

– Katherine Brimberry, co-director and master printer, Flatbed Press

Photos by Christopher Caselli

ARTIST: Trenton Doyle Hancock
DATE: 1999
IMAGE SIZE: 6 x 5 inches
EDITION: 16
PUBLISHER: Flatbed Press

Left
TITLE: Irribl
MEDIUM: Drypoint engraving
with line etching, aquatint and
sugar lift

Right
TITLE: Mammogram
MEDIUM: Copper plate drypoint

"Hancock began *Irribl* using a line-etching technique called 'sugar lift,' which allows the artist to etch a brush stroke very darkly by using a sugar and ink solution to make the marks. The artist then covers the plate with hard ground and soaks the sugar and ink solution off in hot water, leaving the plate open where the brush strokes had been made. That open area is aquatinted and etched. In *Irribl,* a certain amount of 'foul bite' (unintended etching through the hard ground) occurred during the sugar lift. Hancock allowed this unintended change to remain in the piece. The artist started *Mammogram* with a few line etching marks, then elected to add drypoint engraving. Drypoint is a way of directly scratching the copper with a needle to raise a burr of copper along the line. The burr, holding extra amounts of ink, adds the characteristic fuzziness to the edge of the printed line."

– Katherine Brimberry, co-director and master printer, Flatbed Press

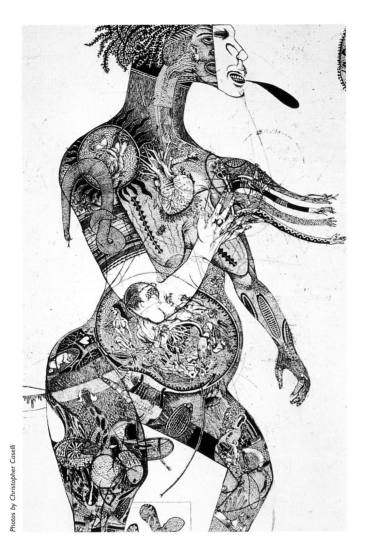

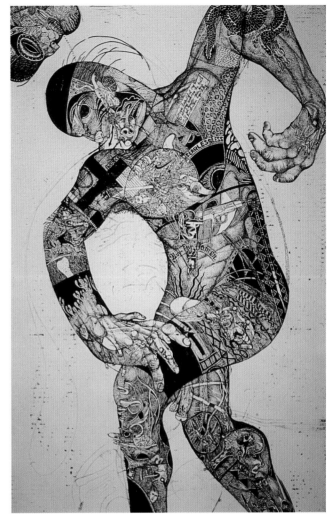

ARTIST: Bob Schneider

DATE: 2000

MEDIUM: Etching

PAPER SIZE: 36 x 24 inches

EDITION: 30

PUBLISHER: Flatbed Press

Left

TITLE: Woman

Right

TITLE: Man

"These line etchings were created on copper by drawing through a hard ground with a traditional etching needle. The plate was etched very deeply, holding enough ink to print dense, dark lines. Wide areas of these lines were reinforced with aquatint in order to hold the ink well."

– Katherine Brimberry, co-director and master printer, Flatbed Press

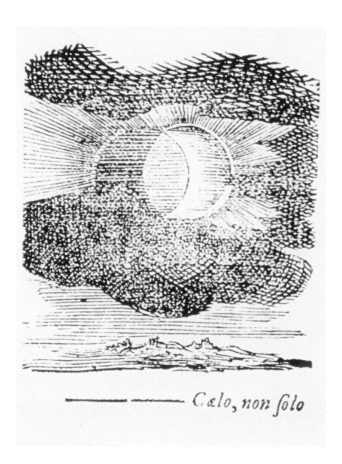

Cælo, non solo

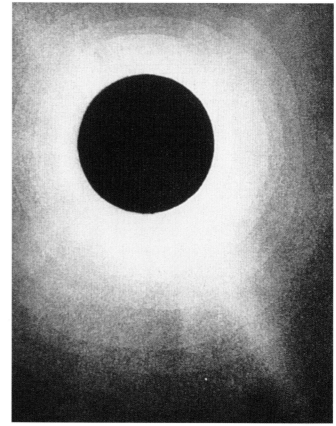

Photos by Ian van Coller

ARTIST: James Turrell
DATE: 1999
PAPER SIZE: 10¹/₂ x 8 inches (each)
EDITION: 40
PUBLISHER: Segura Publishing Company

Left
TITLE: Penzance Eclipse
MEDIUM: Photogravure

Right
TITLE: Penzance Eclipse
MEDIUM: Aquatint

"Turrell's photogravure titled *Penzance Eclipse* is derived from the *Emblemata Sacra,* a Jesuit emblem book of woodcuts produced in Antwerp in 1636. Emblem books contained model designs, here reflecting the 17th-century fascination with light, optics and astronomy. The second image, an aquatint drawn by Turrell, refers to the August 11, 1999, solar eclipse, which Turrell witnessed in Penzance, in Cornwall, England, where he built a sky space to view the phenomenon."

– Joe Segura, owner and master printer, Segura Publishing Company

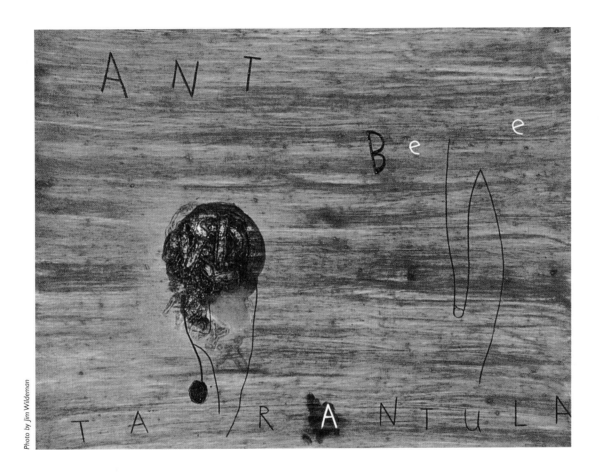

Photo by Jim Wideman

ARTIST: David Lynch

TITLE: Ant Bee Tarantula

DATE: 1998

MEDIUM: Collograph

PAPER SIZE: 34 x 46 inches

EDITION: 20

PUBLISHER: Tandem Press

"David Lynch, the internationally renowned filmmaker, trained as a painter. His prints have a deliberatively primitive and crude quality. Many of his images include words, which are intended to start the viewer thinking about the works, then to consider them as independent forms, shapes and textures. In *Ant Bee Tarantula,* four Versacel plates were used. The first plate uses a blend of brown and gray inks and hand-applied additions in white. The second plate contains a textured background, which Lynch finger-painted onto the plate with Rhoplex. This dried, creating a very hard, textured surface, which was then inked up. The third plate was created in the same way and contained the imagery for the head-like shape. For the fourth plate, Lynch carved the lettering and additional lines using a Dremel tool."

– Paula McCarthy Panczenko, director, Tandem Press

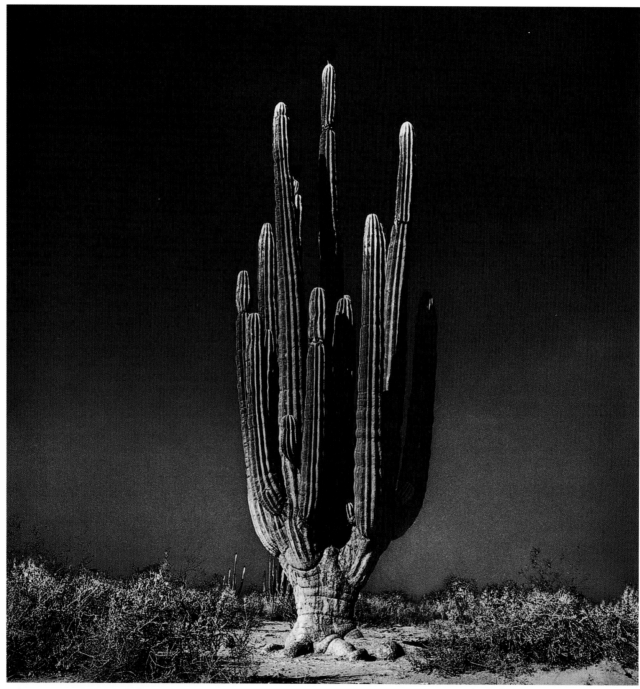

Photo by William Lytch

ARTIST: Graciela Iturbide
TITLE: Centinela
DATE: 1999
MEDIUM: Photogravure
PAPER SIZE: 24⁷/₈ x 24 inches
EDITION: 20
PUBLISHER: Graphicstudio/University of South Florida

"Mexican photographer Graciela Iturbide's portrait of a giant desert cactus is given exquisite life by the rich tones and fine detail of the photogravure process. Photogravure's three-dimensional quality, created by depressions in the printing plate and the thickness of the ink, endows the cactus with a physical presence. This quality has made photogravure a favorite process for photographic portrayals of living beings, architecture and landscapes."

— Noel Smith, publications coordinator, Graphicstudio/University of South Florida

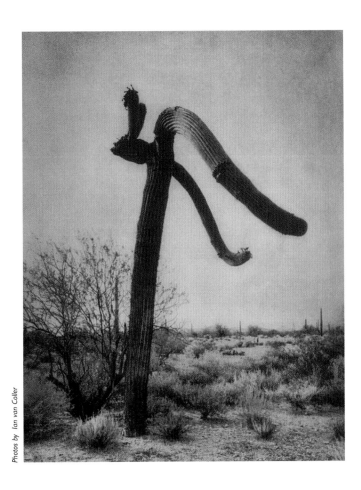

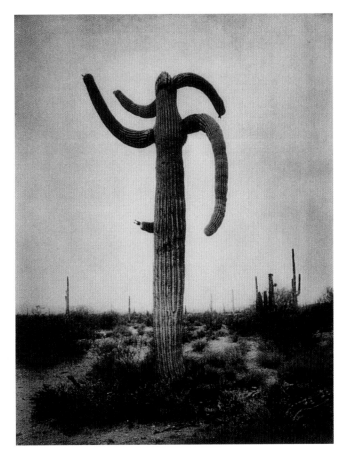

Photos by Ian van Coller

ARTIST: Mark Klett

DATE: 1997

MEDIUM: Photogravure

PAPER SIZE: 24 x 19 inches (each)

EDITION: 40

PUBLISHER: Segura Publishing Company

Images © 1997 by Mark Klett

Left

TITLE: No. 43

Right

TITLE: No. 45

"These are the artist's first photogravures, printed on Gassen Bamboo paper affixed to German Etching paper. The beautiful impressions printed on the translucent paper create a startling visual elegance. The artist says, 'These images come from a series of photographs of saguaros that I have been working on for a long time. Photogravure represents a first step in a different direction for this work; it transforms the images completely.'"

— Joe Segura, owner and master printer, Segura Publishing Company

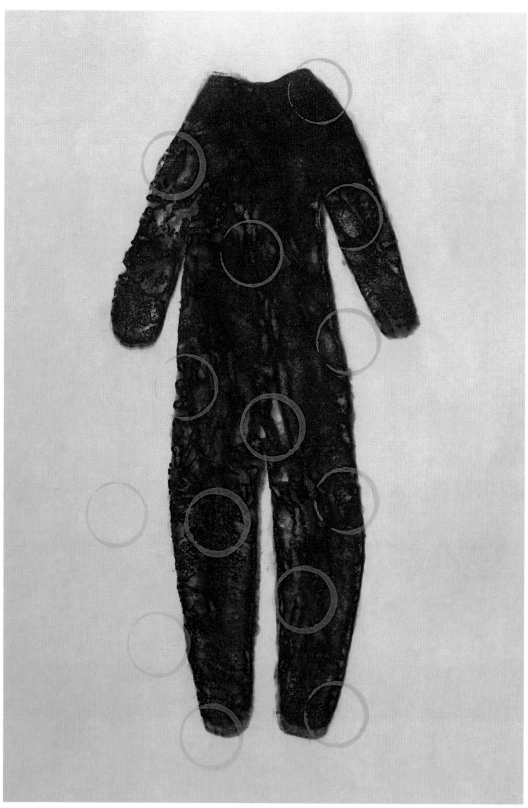

ARTIST: Lynn Beldner
TITLE: Untitled 2000.02
(Blue Suit with Circles)
DATE: 2000
MEDIUM: Color spit bite and
sugar-lift aquatint with chine collé
PAPER SIZE: 22¹/₂ x 30 inches
EDITION: 20
PUBLISHER: Paulson Press

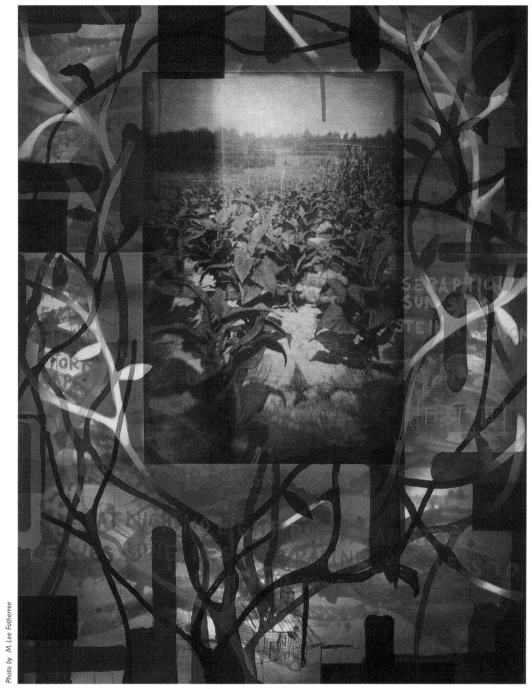

Photo by M. Lee Fatherree

ARTIST: Radcliffe Bailey
TITLE: Tobacco Blues
DATE: 2000
MEDIUM: Color aquatint etching with photogravure and chine collé
PAPER SIZE: 50 x 40 inches
EDITION: 30
PUBLISHER: Paulson Press

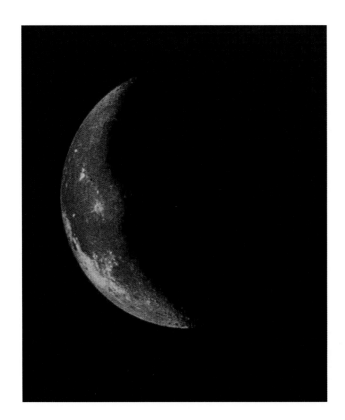

Photos by Ian van Coller

ARTIST: James Turrell
TITLE: Image Stone: Moon Side
DATE: 1999
MEDIUM: Photogravure, aquatint and lithography
PAPER SIZE: 18³/₄ x 15 inches (each)
EDITION: 40
PUBLISHER: Segura Publishing Company

ARTIST: Ross Bleckner
TITLE: Selection
DATE: 1999
MEDIUM: Color, spit-bite
aquatint with soft-ground
etching and chine collé
PAPER SIZE: 40 x 31 inches
EDITION: 50
PUBLISHER: Paulson Press

Photo by M. Lee Fatherree

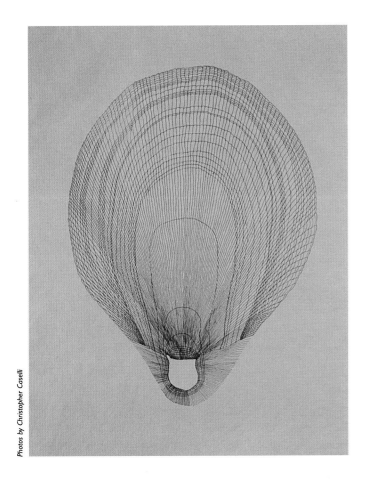

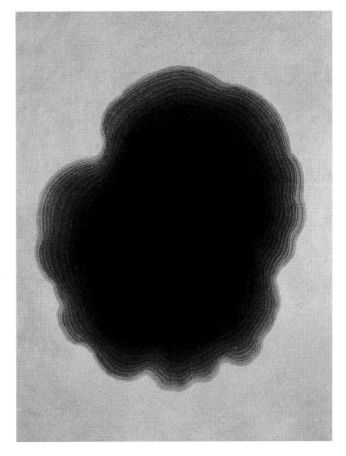

Photos by Christopher Caselli

ARTIST: Liz Ward
DATE: 2000
PAPER SIZE: 24 x 18 inches (each)
EDITION: 40
PUBLISHER: Flatbed Press

Left
TITLE: Fossil
MEDIUM: Line etching

Right
TITLE: Poza
MEDIUM: Aquatint

"For *Fossil*, a hard ground was used to create the delicate linear etching on copper. The yellow aquatint plate that creates the background color was printed on handmade Kitikata paper. The second plate, which carries the linear image, was printed directly over the first printing. *Poza* was created as an aquatint, etched in timed stages. The print is on handmade green Kitikata Japanese paper."

— Katherine Brimberry, co-director and master printer, Flatbed Press

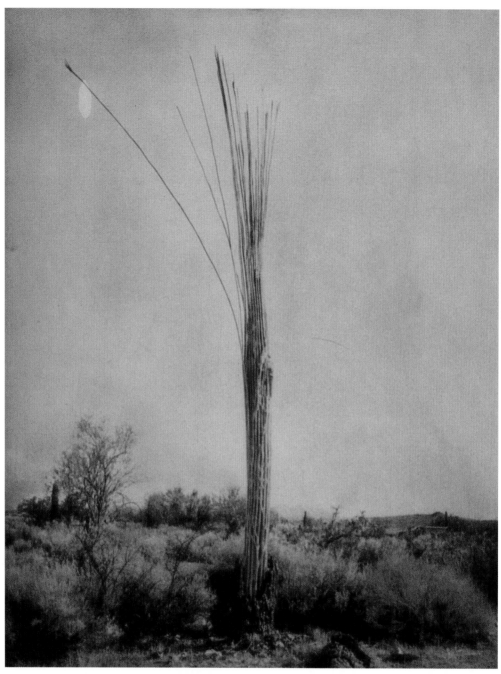

Photo by Ian van Coller

ARTIST: Mark Klett
TITLE: No. 27
DATE: 1997
MEDIUM: Photogravure
PAPER SIZE: 24 x 19 inches
EDITION: 40
PUBLISHER: Segura Publishing Company
Image © 1997 by Mark Klett

Photo by Christopher Caselli

ARTIST: Liz Ward
TITLE: Hoja
DATE: 2000
MEDIUM: Aquatint and line etching
PAPER SIZE: 24 x 18 inches
EDITION: 40
PUBLISHER: Flatbed Press

"Ward, who draws using silver point and watercolor, created this two-plate etching with techniques that simulate the painterliness of watercolor. Using spit bite and white ground (a water-soluble ground that works with aquatint), she added tonal qualities to line etching. The print is on handmade green Kitikata paper."
 – Katherine Brimberry, co-director and master printer, Flatbed Press

ARTIST: Linda Ridgway
DATE: 1999
MEDIUM: Soft-ground etching
PAPER SIZE: 96 x 3¹⁵/₁₆ inches (each)
EDITION: 10
PUBLISHER: Flatbed Press

Left to right
TITLE: Vine Line
TITLE: Mason Dixon Line
TITLE: Dancer

"The Vine Line Suite consists of three soft-ground etchings, each eight feet long by nearly four inches wide. The image on each plate was created by pressing lines into a plate covered with soft-ground etching. When the lines were removed after pressing, their impressions were etched into the copper plates. The plate for each print used graphite ink in the etched areas and transparent ochre ink rolled as a relief color on the surface."
 – Katherine Brimberry, co-director
 and master printer, Flatbed Press

Photos by Christopher Caselli

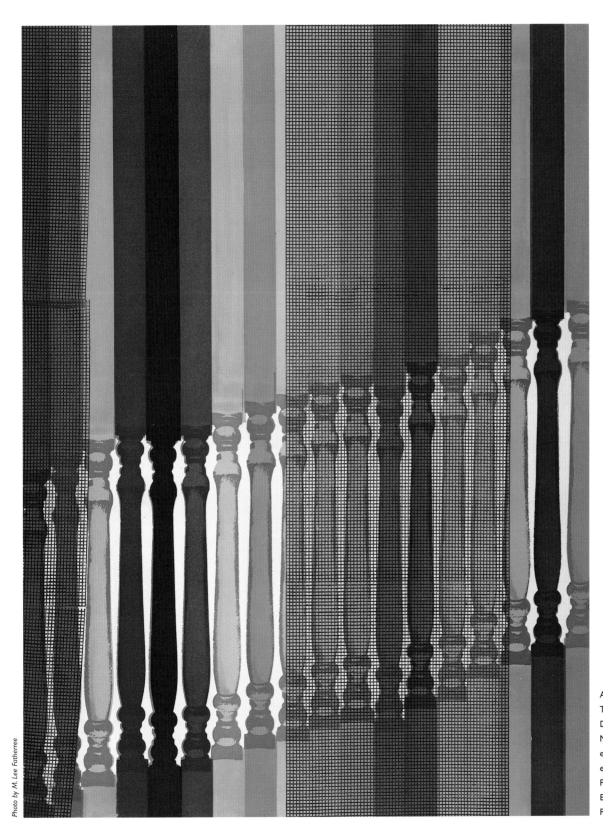

ARTIST: Deborah Oropallo
TITLE: Post Rank
DATE: 1999
MEDIUM: Color aquatint
etching with soft-ground
etching
PAPER SIZE: 46 x 36 inches
EDITION: 35
PUBLISHER: Paulson Press

ARTIST: Enrique Chagoya
TITLE: The Return to Goya's Caprichos
(series of eight)
DATE: 1999
MEDIUM: Etching
PAPER SIZE: 14¹/₂ x 11 inches (each)
EDITION: 40
PUBLISHER: Segura Publishing Company

"This portfolio includes eight etchings
inspired by Goya's *Los Caprichos*. Each
print is based on one of Goya's works,
with the same plate numbers and titles,
but Chagoya has contemporized the
images using the faces of Jesse Helms,
Jerry Falwell, Snow White and Linda Tripp."
 — Joe Segura, owner and master printer,
 Segura Publishing Company

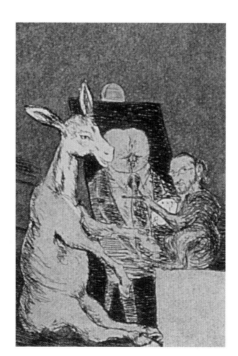

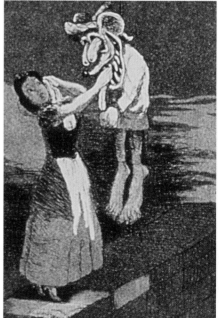

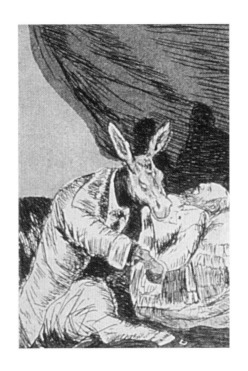

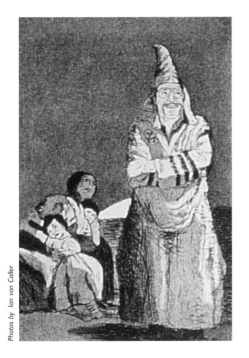
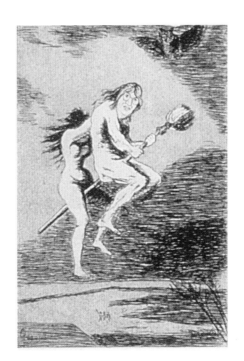

Photo by M. Lee Fatherree

ARTIST: Caio Fonseca
TITLE: Seven String Etching No. 1
DATE: 2001
MEDIUM: Color spit-bite aquatint with soft-ground etching and chine collé
PAPER SIZE: 38 x 48½ inches
EDITION: 50
PUBLISHER: Paulson Press

Photo by M. Lee Fatherree

ARTIST: Margaret Kilgallen

TITLE: Untitled

DATE: 1999

MEDIUM: Sugar-lift aquatint etching with chine collé

PAPER SIZE: 31 x 54 inches

EDITION: 30

PUBLISHER: Paulson Press

"Individual plates were arranged on the press bed like pieces of a puzzle to create this quilt-like composition."
— Pam Paulson, owner and master printer, Paulson Press

LITHOGRAPHY

The Greek root of "lithography" means "writing on stone." Among the four basic printing processes, lithography is the only one for which the discovery of the technique is documented. Aloys Senefelder invented the method for lithography in 1798, and his discovery was quickly followed by artists' early experimentation with the new medium. Both artists and printers were attracted to the similarities between creating an image on a polished lithographic stone and the fluid movement of drawing directly on paper. It's as easy to make a mark on one as the other, and for many artists, lithography's similarity to drawing makes it a natural transition to printmaking. For this reason, lithography's development and evolution include some of art history's most accomplished draftsmen.

Francisco de Goya was among the first important artists to employ the lithographic technique. During the 1820s, in France, he produced theatrical images depicting bullfights. The graphic range of the medium allowed him to imbue this traditional Spanish theme with mythic atmosphere and energy. Experimenting concurrently in France with the relatively new medium was classicist Jean-Auguste-Dominique Ingres, as well as Théodore Géricault and Eugène Delacroix, both artists of the romantic movement who were strongly influenced by Goya's imagery. The prints of this period can be seen as cogent examples of the dramatic power of this medium.

Other nineteenth-century artists who contributed to the development of lithography include the political satirist Honoré Daumier, who alone created more than 4,000 lithographs for newspaper illustrations. Daumier's ambitious subject matter and comedic sensibility were perfectly suited to the medium. The painter Odilon Redon produced lithographs of symbolist imagery that later influenced the surrealist movement. The facility of both Edgar Degas and

ARTIST: Red Grooms
TITLE: Jackson in Action
DATE: 1997
MEDIUM: Color 3D lithograph
PAPER SIZE: 26 x 33 x 7¼ inches
EDITION: 75
PUBLISHER: Shark's Ink

"The three-dimensional lithographs we have done with Red Grooms typically begin as paper maquette's or models, which Grooms creates from paper. We then take the maquette apart and lay all the pieces out flat. Lithographic plates are then drawn for each color used in the print. The lines for folds, tabs and areas to be cut are also included on the plates. There may be as many as six flat prints assembled to create the final three-dimesional print. *Jackson in Action* was printed in 14 colors from 14 plates on two sheets of paper."

— Bud Shark, director and master printer, Shark's Ink

Henri de Toulouse-Lautrec as draftsmen allowed them to create a range of effects for their prints, while retaining much of the same visual immediacy that distinguishes their paintings.

Prominent artists continued to experiment with the lithographic medium during the twentieth century. Henri Matisse, Pablo Picasso, Joan Miró, Henry Moore, Jasper Johns and Robert Rauschenberg all pushed the technical limits of the process in order to expand their pictorial vocabularies.

Lithography is a process in which the printed and nonprinted areas exist on the same plane (a circumstance termed "planographic"). Because lithography is dependent on the antipathy between grease and water, the artist uses crayons,

Photo by Narcissa Segura

ARTIST: Enrique Chagoya and Alberto Rios
TITLE: You Are Here (series of 6 prints)
DATE: 2000
MEDIUM: Lithograph
PAPER SIZE: 17 x 17 inches
EDITION: 60
PUBLISHER: Segura Publishing Company

"Enrique Chagoya produced this portfolio of maps in collaboration with poet Alberto Rios. Each lithograph in the *You Are Here* suite is stamped with one of Chagoya's unique rubber stamps and onto each is printed a poem by Alberto Rios. The first map, seen here, is fashioned after the maps of early explorers and depicts the United States in the shape of Cuba, surrounded by a body of water in the shape of the U.S."

– Joe Segura, owner and master printer, Segura Publishing Company

pencils and washes with a high grease content to create the image on a flat surface — usually fine-grained limestone, or a zinc or aluminum plate. When the stone or plate is inked and printed on paper, the same marks and tonal values will appear in reverse.

Once the artist completes the drawing, the stone or plate is chemically treated to protect the image. (If the final image contains more than one color, the artist will make a separate drawing for each color.) The artist coats the surface — first with rosin, then with an even application of talc — to allow the chemical solution to lie closer to the grease drawing. Next, a solution of gum arabic and nitric acid, called an "etch," is applied to the stone. Later, when the oil-based ink is rolled onto the stone, the ink will adhere only to the greasy image.

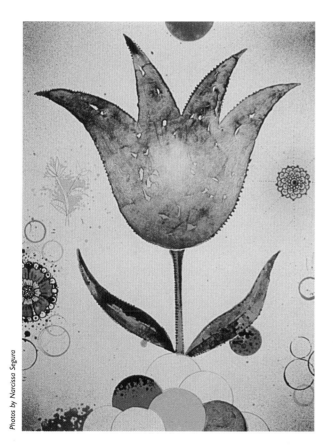
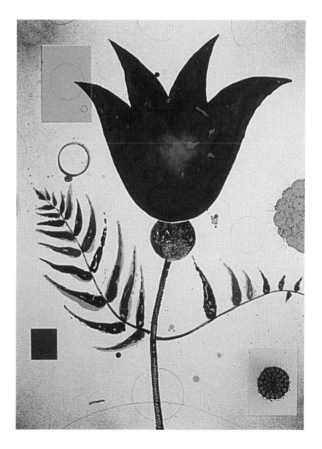

Photos by Narcissa Segura

ARTIST: Dan Rizzie
DATE: 2000
MEDIUM: Lithograph
PAPER SIZE: 34 x 26 inches (each)
EDITION: 40
PUBLISHER: Segura Publishing Company

Left
TITLE: Tulipa

Right
TITLE: Panicula

"Dan Rizzie has always been interested in botanical studies and a few years ago, he began to make drawings and prints of the flowers he had planted. The two-dimensional, somewhat abstract floral patterning of Islamic architectural decoration has influenced his art. He once accidentally put a wet jar on a paper, which led to his experimentation with the perfect circle like the ones on *Tulipa* and *Panicula*."

– Joe Segura, owner and master printer, Segura Publishing Company

At this point, the stone is first dampened with water and then rolled with ink. The width of the roller must be larger than the image to allow for a consistent application of ink. The water does not affect the image; it simply allows the non-printing areas of the stone to remain clean, since the water repels the ink. The artist is now ready to begin the trial proofs (experimenting with ink color and different papers).

The procedure remains the same for printing more than one color. Multicolor lithographs usually require that a separate stone or plate be used for each color. As with painting, lithographic printing effects rely on the transparency or opacity of the layered color. The possibilities are endless; overprinting techniques can produce both subtle and dramatic shifts in colors and surface variation.

The versatility of lithography has caused it to become the most frequently used method of planographic printing. Because of the various ways in which images can be created, they seldom have the distinctive characteristics identified with woodcuts, etchings or screenprints. Lithographs often look crayon-like or grainy, but they can also resemble watercolors. For artists who prefer this extensive range of effects and who prefer to use tools associated with drawing and painting in a medium that allows for the duplication of impressions, lithography becomes an important medium of expression.

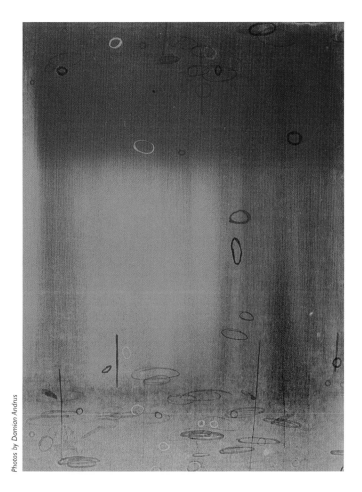

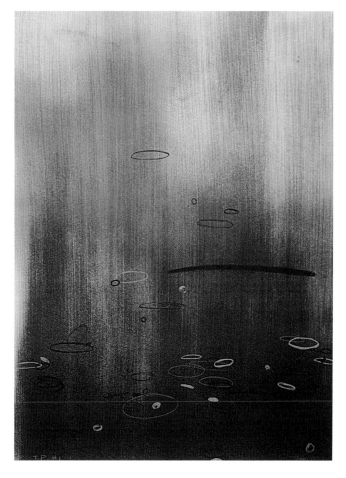

Photos by Damian Andrus

ARTIST: Emmi Whitehorse

DATE: 2000

MEDIUM: Five-color lithograph with hand painting

PAPER SIZE: 24 x 18 inches (each)

EDITION: 20

PUBLISHER: Tamarind Institute

Left

TITLE: Silent Rain

Right

TITLE: Rushing Water

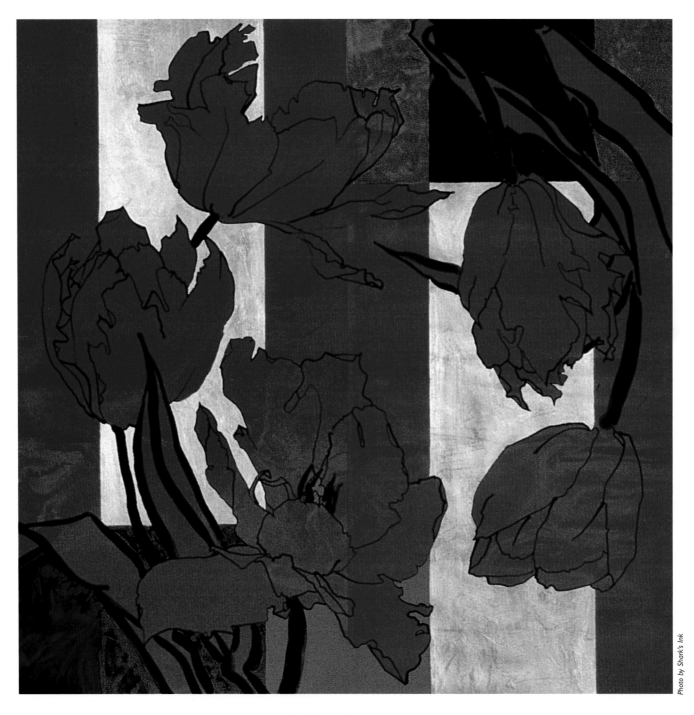

ARTIST: Robert Kushner
TITLE: Tulip Tarantella
DATE: 2000
MEDIUM: Lithograph with gold leaf
PAPER SIZE: 33 x 33 inches
EDITION: 30
PUBLISHER: Shark's Ink

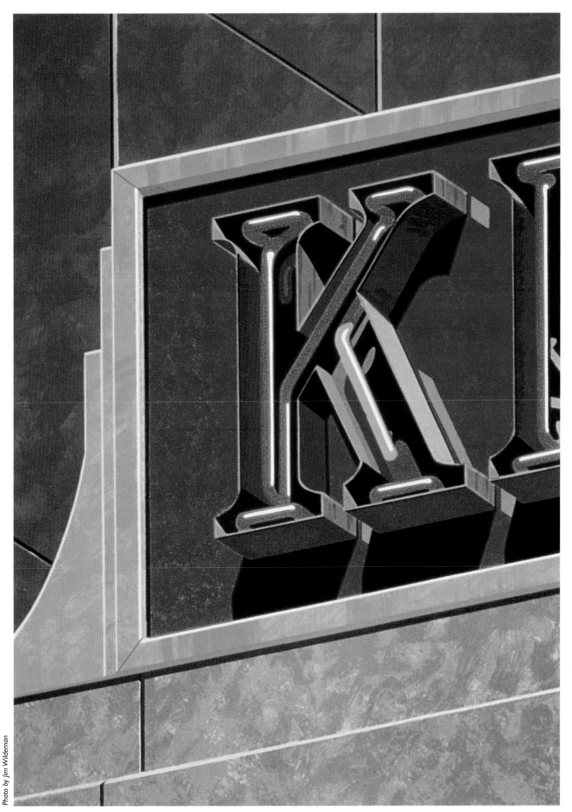

Photo by Jim Wildeman

ARTIST: Robert Cottingham
TITLE: An American Alphabet: K
DATE: 1997
MEDIUM: Color lithograph
PAPER SIZE: 31 x 23 inches
EDITION: 60
PUBLISHER: Tandem Press

"Known for his realist paintings of American iconography, Robert Cottingham has teamed up with Tandem Press to create a large and complex series of lithographs using the American alphabet as its subject. Although Cottingham's *American Alphabet* lithography series is based on an earlier series of his paintings, all of the textures and colors used were created specifically for each individual print. *An American Alphabet: K* was created with hand-cut color separations using 16 plates and 30 colors."
— Paula McCarthy Panczenko, director, Tandem Press

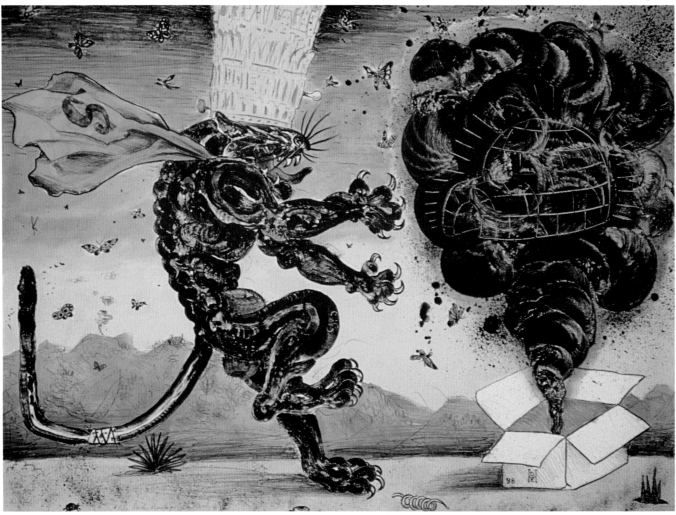

ARTIST: Don Ed Hardy
PUBLISHER: Shark's Ink

This page
TITLE: Rocky Mambo #5
DATE: 1999
MEDIUM: Hand-colored lithograph
PAPER SIZE: 22 x 30 inches
EDITION: 10

Facing page, left
TITLE: Storm Dragon
DATE: 2001
MEDIUM: Color Lithograph
PAPER SIZE: 47¹/₂ x 18 inches
EDITION: 20

Facing page, right
TITLE: Sea Dragon
DATE: 2001
MEDIUM: Lithograph with metallic powder
PAPER SIZE: 47¹/₂ x 18 inches
EDITION: 20

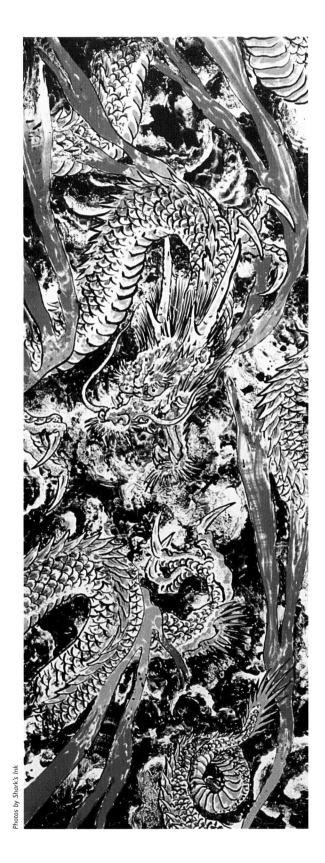

Photos by *Shark's Ink*

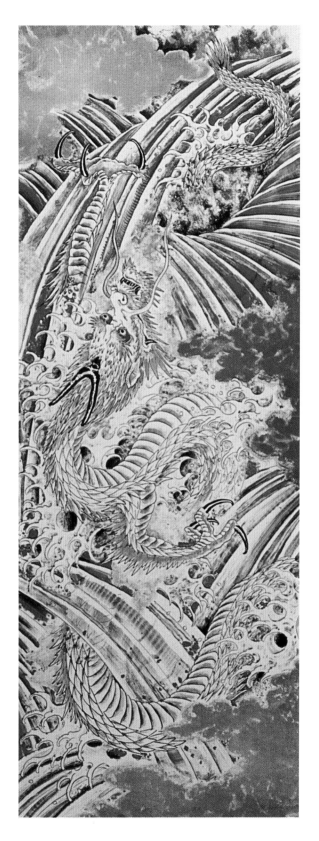

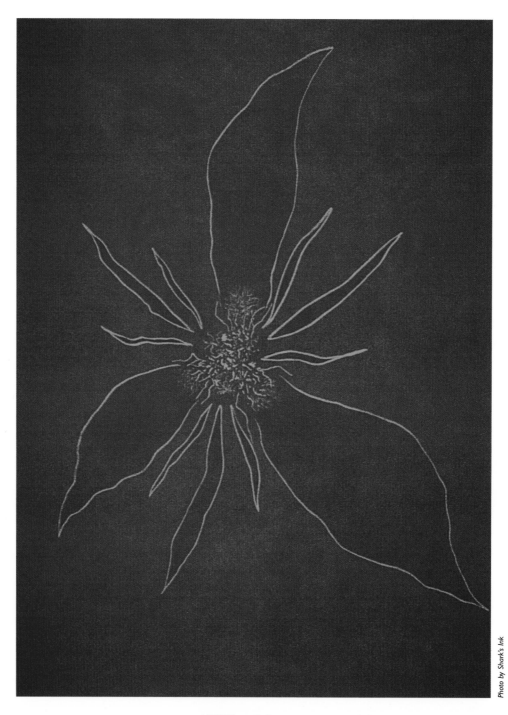

Photo by Shark's Ink

ARTIST: James Surls
TITLE: Blood Flower
DATE: 1999
MEDIUM: Color lithograph
PAPER SIZE: 30 x 22 inches
EDITION: 15
PUBLISHER: Shark's Ink

Photo by Damian Andrus

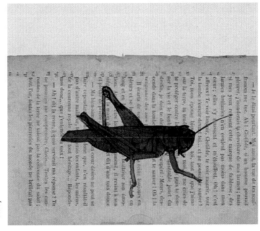

ARTIST: Lance Letscher

TITLE: Grasshopper

DATE: 2000

MEDIUM: 1-color lithograph with collé antique book page and hand coloring

PAPER SIZE: 9 ⁵/₈ x 10 ⁷/₈ inches

EDITION: 10

PUBLISHER: Tamarind Institute

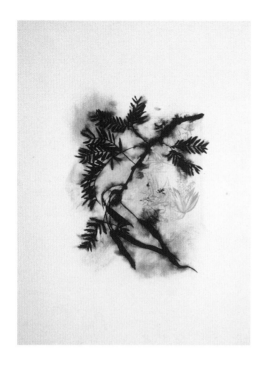
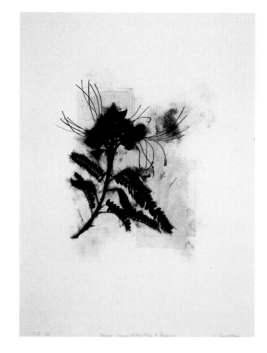
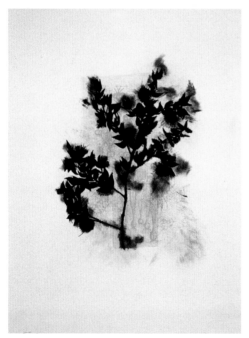
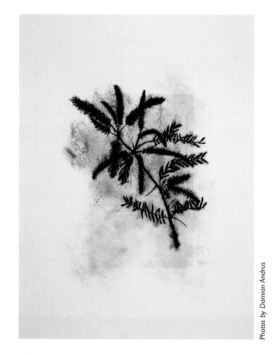

Photos by Damian Andrus

ARTIST: Susan Davidoff

DATE: 2000

MEDIUM: Two-color lithograph with dirt

PAPER SIZE: 30¹/₈ x 22 inches (each)

EDITION: 20

PUBLISHER: Tamarind Institute

Clockwise from above left

TITLE: Equinox – Summer Solstice/Mesquite No. 2

TITLE: Equinox – Summer Solstice/Bird of Paradise

TITLE: Equinox – Summer Solstice/Mesquite No. I

TITLE: Equinox – Summer Solstice/Creosote

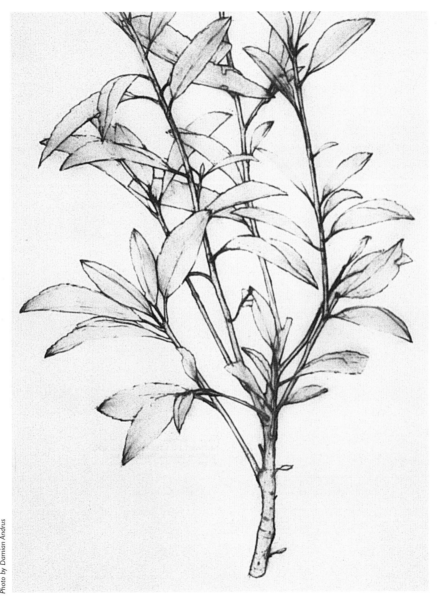

Photo by Damian Andrus

ARTIST: Lance Letscher
TITLE: Plant Form
DATE: 2000
MEDIUM: Two-color lithograph with collé antique book page and hand-smeared ink
PAPER SIZE: 18$^1/_2$ x 15 inches
EDITION: 20
PUBLISHER: Tamarind Institute

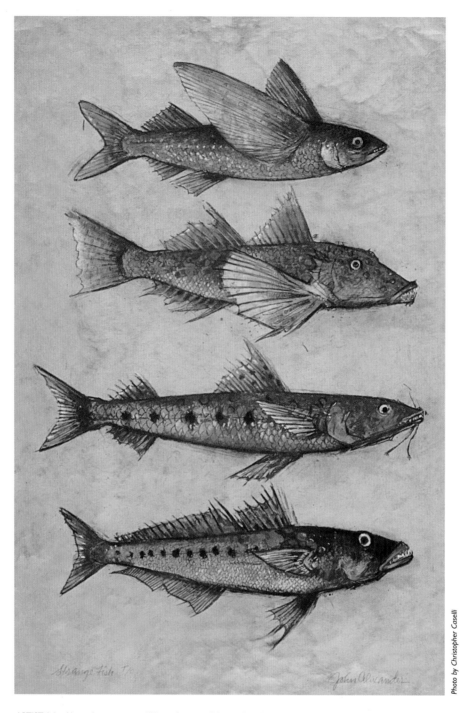

Photo by Christopher Caselli

ARTIST: John Alexander
TITLE: Strange Fish
DATE: 2001
MEDIUM: Multicolor lithograph
PAPER SIZE: 30 x 22 inches
EDITION: 35
PUBLISHER: Flatbed Press

"Using aluminum lithographic plates, John Alexander drew approximately ten images, creating a multicolored print. He has used both traditional lithographic crayon and a new, compressed toner crayon to make the litho plates and has printed on handmade Nepalese paper. The effect reads much like vine charcoal."

– Katherine Brimberry, co-director and master printer, Flatbed Press

Photo by Christopher Caselli

ARTIST: Leonard Lehrer

TITLE: Untitled (III)

DATE: 2000

MEDIUM: Lithograph

PAPER SIZE: 44 x 30 inches

EDITION: 30

PUBLISHER: Flatbed Press

"Leonard Lehrer has created this image, along with a series of like images, on very large aluminum lithographic plates. Each image has been hand-drawn with litho crayon."

– Katherine Brimberry, co-director and master printer, Flatbed Press

Photos by Damian Andrus

ARTIST: Lance Letscher

DATE: 2000

MEDIUM: One-color lithograph with collé antique book page

PUBLISHER: Tamarind Institute

Left

TITLE: Dark Brown Bird

PAPER SIZE: 12¹/₂ x 11 inches

EDITION: 10

Right

TITLE: Bird Split in Half

PAPER SIZE: 8¹/₂ x 7⁷/₈ inches

EDITION: 20

ARTIST: Jane Rosen

TITLE: Remy

DATE: 2000

MEDIUM: Lithograph

PAPER SIZE: 22 x 15 inches

EDITION: 4

PUBLISHER: Segura Publishing Company

"*Remy* is an exquisitely drawn one-color lithograph. It was drawn on stone and printed on a gray Rives paper. This work conveys the artist's plea for the preservation and protection of wildlife."

— Joe Segura, owner and master printer, Segura Publishing Company

Photo by Jim Wildeman

ARTIST: Art Spiegelman
TITLE: Crossroads
DATE: 1997
MEDIUM: Lithograph
PAPER SIZE: 25 x 17³/₄ inches
EDITION: 100
PUBLISHER: Tandem Press

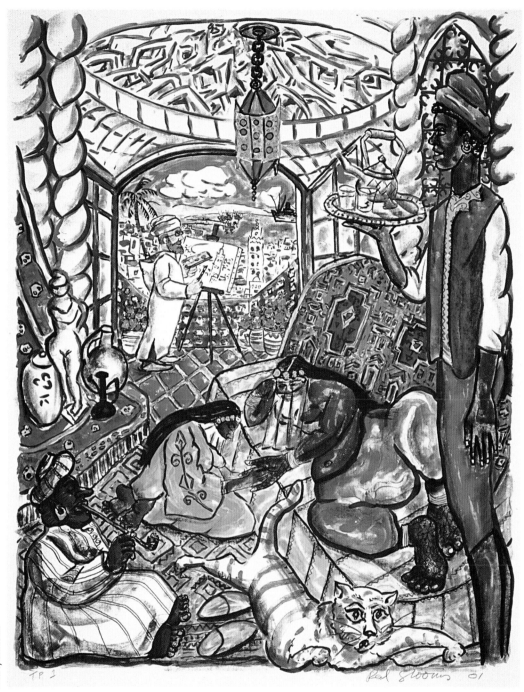

ARTIST: Red Grooms ·
TITLE: Matisse in Tangiers
DATE: 2001
MEDIUM: Color lithograph
PAPER SIZE: 37$\frac{1}{2}$ x 29$\frac{1}{2}$ inches
EDITION: 45
PUBLISHER: Shark's Ink

ARTIST: Sean Mellyn
TITLE: Anonymous
DATE: 2001
MEDIUM: Five-color lithograph
with hand coloring
PAPER SIZE: 22$\frac{1}{4}$ x 17 inches
EDITION: 20
PUBLISHER: Tamarind Institute

Photo by Damian Andrus

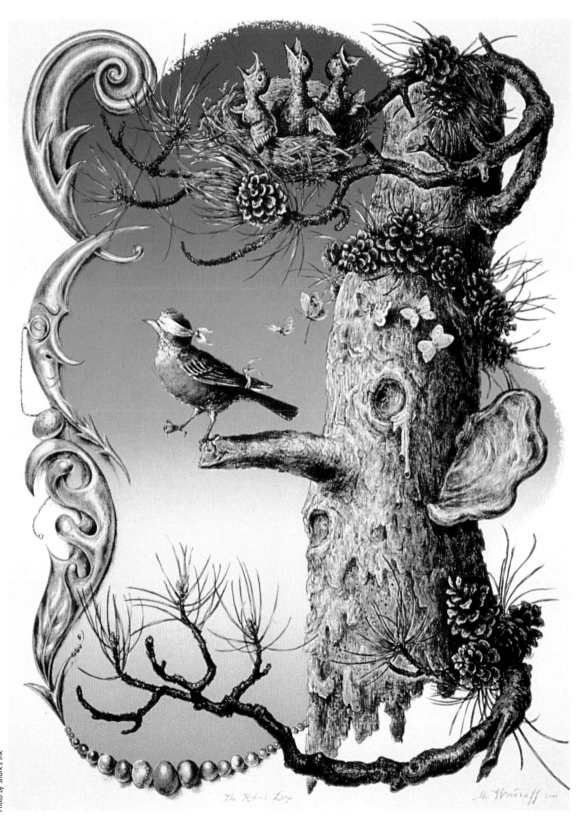

The Robin's Leap

ARTIST: Thomas Woodruff
TITLE: The Robin's Leap
DATE: 2000
MEDIUM: Color lithograph
with collage
PAPER SIZE: 30 x 22 inches
EDITION: 25
PUBLISHER: Shark's Ink

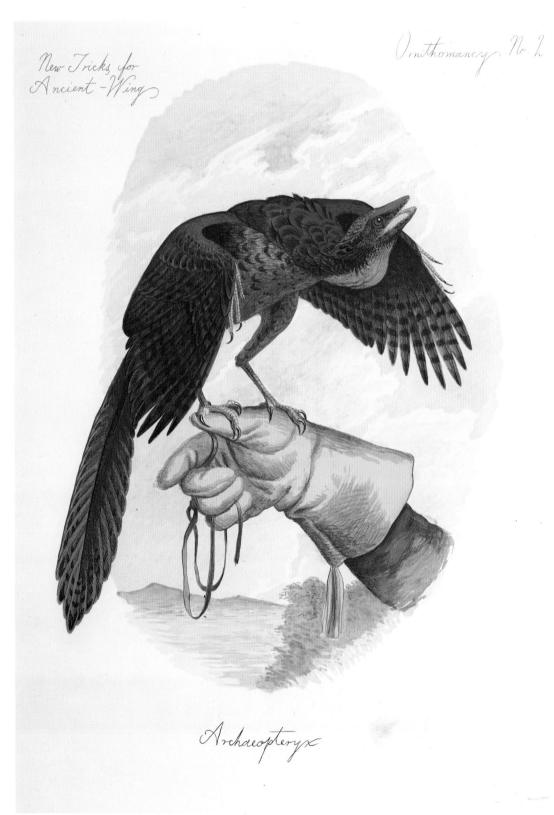

New Tricks for Ancient-Wing

Ornithomancy. No. 2

Archaeopteryx

ARTIST: Walton Ford
TITLE: New Tricks for Ancient Wings
DATE: 2001
MEDIUM: Lithograph
PAPER SIZE: 36¼ x 26 inches
EDITION: 60
PUBLISHER: Derriere L'Etoile Studios

Photo by Jean Vong

ARTIST: April Gornik
TITLE: Radiant Light
DATE: 2001
MEDIUM: Lithograph
PAPER SIZE: 31 x 37 inches
EDITION: 75
PUBLISHER: Derriere L'Etoile Studios

Photo by Damian Andrus

ARTIST: Juan Sánchez

TITLE: I Am Ame/Rican

DATE: 1998

MEDIUM: Nine-color lithograph with chine collé

PAPER SIZE: 21³/₈ x 30¹/₈ inches

EDITION: 20

PUBLISHER: Tamarind Institute

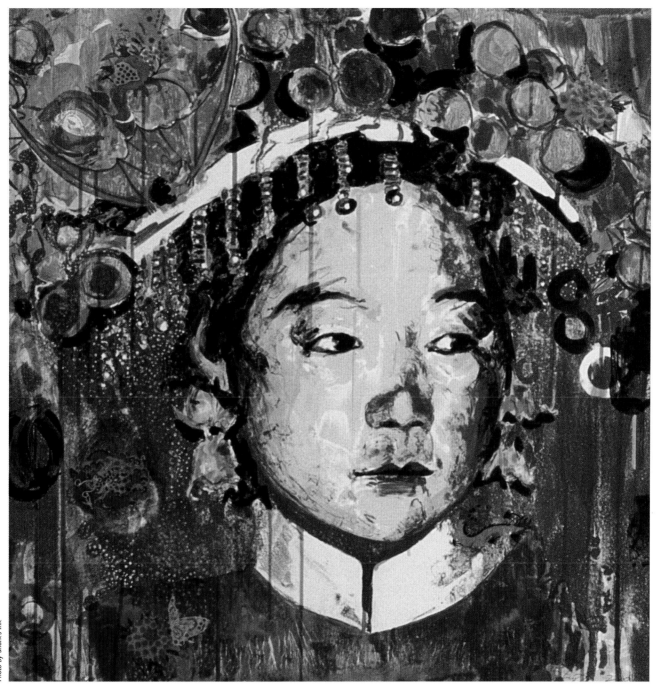

Photo by Shark's Ink

ARTIST: Hung Liu
TITLE: Unofficial Portraits (The Bride)
DATE: 2001
MEDIUM: Lithograph with collage
PAPER SIZE: 30 x 30 inches
EDITION: 30
PUBLISHER: Shark's Ink

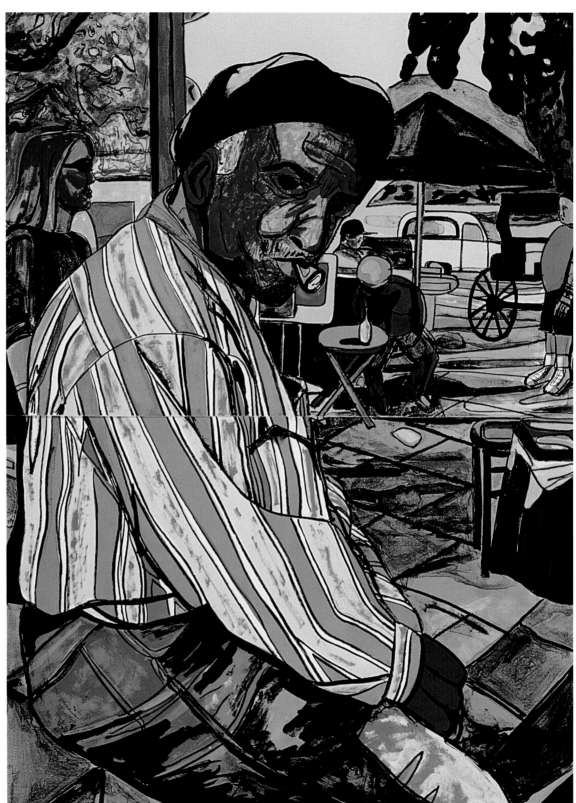

ARTIST: Willie Birch
TITLE: Big Man
DATE: 2000
MEDIUM: Ten-color,
two-part lithograph
PAPER SIZE: 50 x 36½
inches
EDITION: 15
PUBLISHER: Tamarind
Institute

Photo by Damian Andrus

Photo by Shark's Ink

ARTIST: Yvonne Jacquette
TITLE: Dusk Descending
DATE: 2000
MEDIUM: Lithograph with hand coloring
PAPER SIZE: 33$^{1}/_{4}$ x 27 inches
EDITION: 30
PUBLISHER: Shark's Ink

Photo by Damian Andrus

ARTIST: Liliana Porter
TITLE: Dreamer
DATE: 2000
MEDIUM: Four-color lithograph with pillow
PAPER SIZE: 13 x 11 inches
EDITION: 20
PUBLISHER: Tamarind Institute

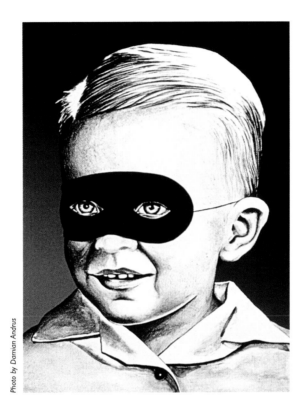

Photo by Damian Andrus

ARTIST: Sean Mellyn
TITLE: Boy with Mask
DATE: 2001
MEDIUM: Four-color lithograph, 3D nose, mask
PAPER SIZE: 20 3/8 x 17 inches
EDITION: 18
PUBLISHER: Tamarind Institute

A CRASH! Is it the Thunder? The Economy? Motorized Vehicles, maybe? (The end of a Bad Trip?). Could it simply be an Overloaded Computer, or the sound of an Overburdened Heart Breaking? Who Knows? Certainly not this Unhappy Hooligan, a newsprint Star at the Dawn of the Century, whose Career Crashed in the Thirties when his creator's eyes dimmed. He sits in the shadows, awaiting the Century's End.

Photo by Jim Wildeman

ARTIST: Art Spiegelman

DATE: 1997

MEDIUM: Lithograph

PAPER SIZE: 21 x 33 inches

EDITION: 50

PUBLISHER: Tandem Press

Above

TITLE: Lead Pipe Sunday #2
(inside)

Facing page

TITLE: Lead Pipe Sunday #2
(front/back)

"Art Spiegelman's *Lead Pipe Sunday #2* was Tandem Press's first double-sided print. Fifteen plates and one stone were utilized to create this print. The key drawing in black was done by the artist on a lithographic stone. Eight plates were then made, incorporating 14 colors on the inside of the print. On the front/back, seven plates were used to run ten colors. Designed to mimic the Sunday comics, this print is scored and folded down the middle and displayed in a Plexiglas freestanding frame designed by the artist."

— Paula McCarthy Panczenko, director, Tandem Press

Photo by Jim Wildeman

Photos by Damian Andrus

ARTIST: Mary Snowden
DATE: 2000
PUBLISHER: Tamarind Institute

Above
TITLE: Annie's Chores
MEDIUM: Five-color lithograph
PAPER SIZE: 21 1/2 x 37 3/8 inches
EDITION: 15

Facing page
TITLE: Kitchen Polka
MEDIUM: Nine-color lithograph
PAPER SIZE: 27 1/2 x 27 5/8 inches
EDITION: 20

Photos by Damian Andrus

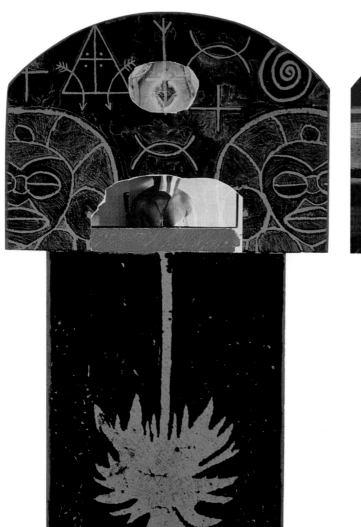

Photos by Damian Andrus

ARTIST: Juan Sánchez
DATE: 1998
PUBLISHER: Tamarind Institute

Left
TITLE: Afro-Taino
MEDIUM: One-color hinged lithograph
with collage and hand coloring
PAPER SIZE: 49⅝ x 30 inches
EDITION: 15

Right
TITLE: Life is a Parade
MEDIUM: Four-color lithograph
with collage and hand coloring
PAPER SIZE: 50 x 30⅛ inches
EDITION: 16

Photo by Jim Wildeman

ARTIST: Italo Scanga
TITLE: Golden Statue
DATE: 1993
MEDIUM: Lithograph
PAPER SIZE: 30 x 22 inches
EDITION: 30
PUBLISHER: Tandem Press

"Italo Scanga was born in Italy and moved to the United States when he was fifteen. He uses Italian imagery in his work, including landscapes, pottery and statuary. His work also has a stained glass quality in its segmentation of the images. This lithograph uses 11 plates and 12 colors."

– Paula McCarthy Panczenko, director, Tandem Press

Photos by Narcissa Segura

ARTIST: Enrique Chagoya and Alberto Rios
TITLE: You Are Here (series of six prints)
DATE: 2000
MEDIUM: Lithograph
PAPER SIZE: 17 x 17 inches (each)
EDITION: 60
PUBLISHER: Segura Publishing Company

"The second map (top left) in this series of six prints is a thirteenth-century Asian celestial map to which Chagoya has added his own distinctive constellations. The third, a genome map, depicts human chromosomes encased in a house. The next (bottom left) is an astronomical map showing an image of the earth surrounded by funky 'astro-trash.' The final image is a map of relationships showing different geometric shapes and colors as they relate to various ethnic groups."
— Joe Segura, owner and master printer, Segura Publishing Company

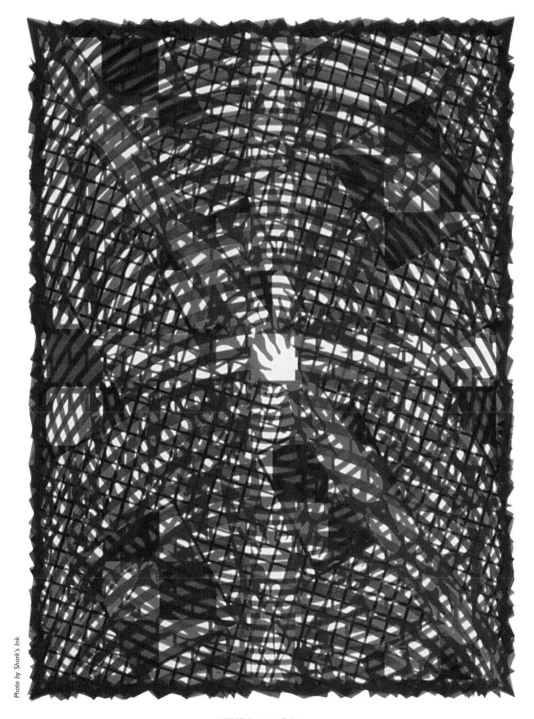

Photo by Shark's Ink

ARTIST: Bernard Cohen
TITLE: Colorado I
DATE: 1999
MEDIUM: Color lithograph
PAPER SIZE: 27 $^3/_8$ x 21 inches
EDITION: 26
PUBLISHER: Shark's Ink

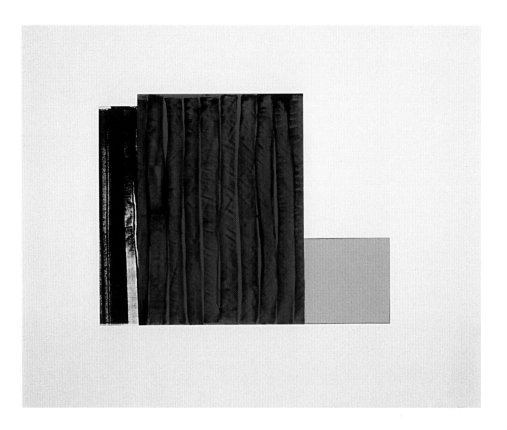

ARTIST: Stephanie Weber
DATE: 2000
EDITION: 8
PUBLISHER: Tamarind Institute

Above
TITLE: Carmen
MEDIUM: Four-color lithograph with collage
and hand coloring
PAPER SIZE: 28¹/₂ x 36⁵/₈ inches

Below
TITLE: Striations
MEDIUM: Three-color lithograph collage
PAPER SIZE: 28 x 33⁷/₈ inches

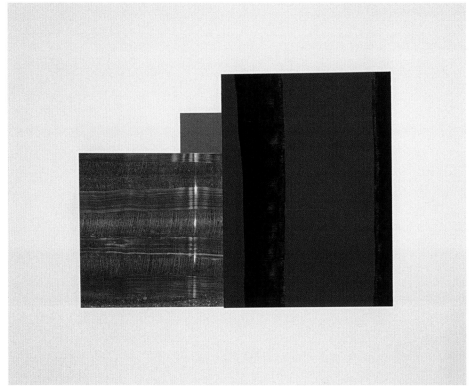

Photos by Damian Andrus

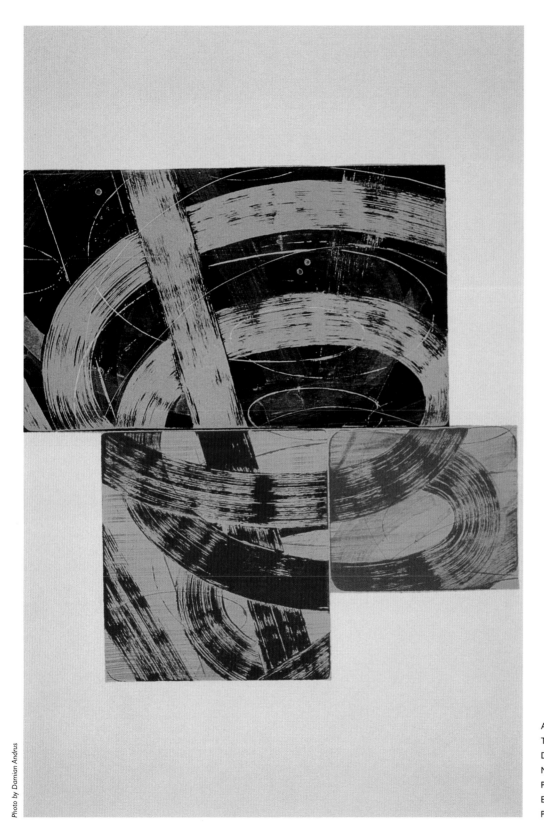

ARTIST: David Row
TITLE: Lazo
DATE: 1999
MEDIUM: Eight-color lithograph
PAPER SIZE: 28 x 28 inches
EDITION: 20
PUBLISHER: Tamarind Institute

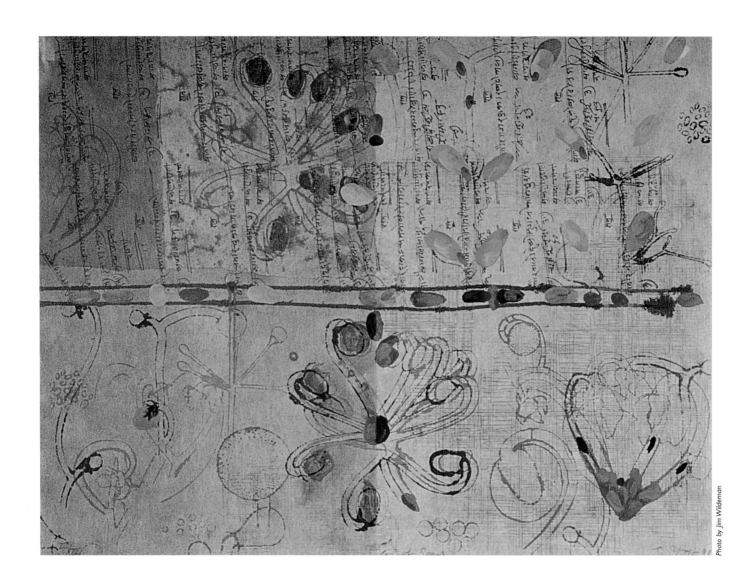

Photo by Jim Wildeman

ARTIST: Judy Pfaff
TITLE: Cost of Seed
DATE: 1998
MEDIUM: Lithography, encaustic, hand-applied dye
PAPER SIZE: 18 x 24 inches
EDITION: 20
PUBLISHER: Tandem Press

"In *Cost of Seed,* Pfaff uses imagery from Indian Sanskrit ledger books and laser stencils of plants from scientific journals. Half of each print was dipped in fabric dye to create luminous green hues. Finally, the artist hand-applied encaustic paint to each print."
— Paula McCarthy Panczenko, director, Tandem Press

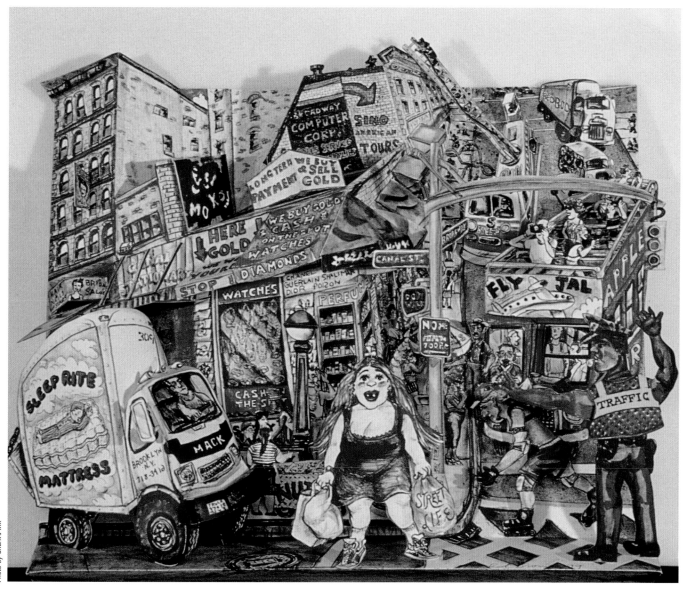

ARTIST: Red Grooms

TITLE: Traffic!

DATE: 1999

MEDIUM: Color 3D lithograph

PAPER SIZE: 23³/₈ x 28¹/₈ x 10 inches

EDITION: 75

PUBLISHER: Shark's Ink

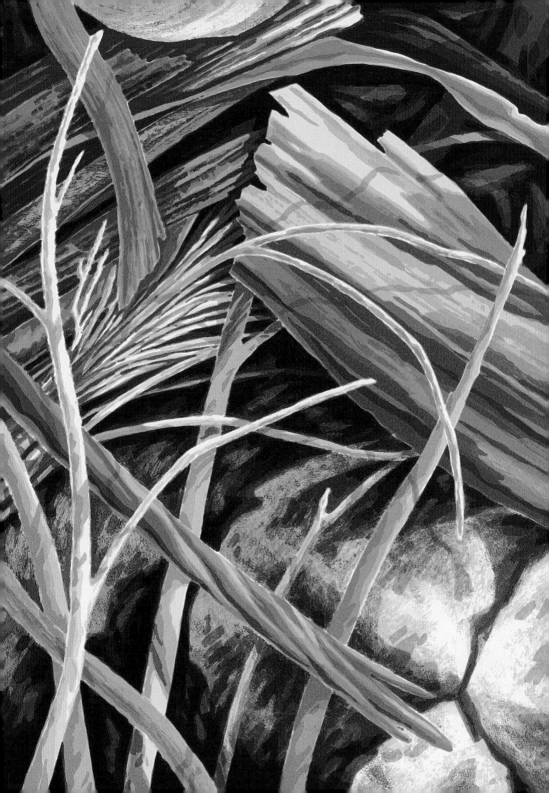

SCREENPRINTING

Screenprinting is the youngest of the four basic printing processes; for artists, it is also the most important printing technique since the discovery of lithography in 1798. The method, which involves pressing ink through a silk or synthetic screen partially blocked by a stencil, developed concurrently in France and England between 1870 and 1910.

At first, screenprinting was used commercially, primarily for posters. Because of this, its development and early usage were not well documented. In the 1930s, artists adopted the process, using the term "serigraph" (from the Latin *sericum*, for silk) to distinguish their work from the commercial application. Today, "screenprinting" is the most commonly used term for this technique, and tough, man-made fabrics have largely replaced silk.

Screenprinting developed from the stencil process, a rudimentary technique that has existed throughout the history of printmaking. Between 500 and 1000 A.D., the Chinese introduced stencil duplicates of Buddha on precious silks. During the same period, the Japanese used stencils to create intricate printed patterns on fabrics. The technique was introduced in Europe in the late 1400s, following Marco Polo's travels to China.

Stenciling is a simple process and can be used by artists of all abilities to create basic forms. To make a stencil print, a shape or pattern is first knife-cut from dense paper, acetate or metal. This stencil acts as a guide, blocking the areas that won't be printed. As ink or paint is pressed through the cutout, the patterned image is then re-created on the surface directly beneath the stencil. This basic technique of printing reveals simple positive (printed) and negative (unprinted) areas on the paper. The printed image can appear either flat or voluminous, depending on how the artist applies the ink or paint. A roller or squeegee

ARTIST: Catherine Kernan
TITLE: Sticks #2
DATE: 1988
MEDIUM: 18-color screenprint
PAPER SIZE: 29 x 21½ inches
EDITION: 61
PUBLISHER: Stewart & Stewart

"In *Sticks #2*, Catherine Kernan combines studies from her trips to the Irish countryside to create a screenprint that displays similar visual qualities to those seen in her primary printmaking medium: intaglio."

 – Norm Stewart, partner and master printer, Stewart & Stewart

produces a sharper image, while a brush yields a softer effect. In order to print more than one color, additional shapes can be cut within the same stencil. Each color is printed separately.

In the early twentieth century, the French developed a process called *pochoir* – the French word for stencil. The *pochoir* method allows the artist to add new shapes or hand-colored patterns to an image as he or she dabs ink or paint through the stencil. This simple technique is most often combined with monochromatic etchings or lithographs to create areas of modulated color.

The screenprinting process took hold in the United States during the first half of the twentieth century. Initially, it was adopted by commercial advertisers, who recognized the technique's potential for producing bold graphic images at low costs. Following the economic depression of the 1930s, artists began to recognize the unique visual properties and accessibility of the medium; their enthusiastic adoption and use of screenprinting brought the technique to the attention of an international art audience. Screenprinting's simple yet powerful graphic properties became identified with the American post-industrial landscape, which, at the time, was an important new subject matter for artists.

Coincidentally, because of its association with American manufacturing, screenprinting reinforced the mediate view of the urban environment shared by the pop art painters Red Grooms, Andy Warhol and Roy Lichtenstein. Screenprinting is unlike other printing processes in that the screen acts as an intermediate surface; still, the print is the result of a direct impression. For many pop artists, the screenprinting process itself seemed to mimic the content of their work. During this same time, other innovative artists, including Marcel Duchamp, began experimenting with screenprinting in order to reconcile its commercial applications with a more personal iconography.

©1999 www.StewartStewart.com

ARTIST: Susan Crile
TITLE: Assisi
DATE: 1999
MEDIUM: 11-color screenprint
PAPER SIZE: 41 x 28 1/2 inches
EDITION: 62
PUBLISHER: Stewart & Stewart

"The Italian influence in *Assisi* and *Assisi Reassembled* comes from Susan Crile's extensive travels and experiences as a resident in painting at the American Academy in Rome. The *Assisi* screenprints depict the thirteenth-century ceiling paintings in the Basilica of St. Francis (San Francesco) in Assisi, Italy. In 1997, a violent earthquake destroyed the frescoes only months after Crile had recorded the ceiling paintings in drawing and photography."

– Norm Stewart, partner and master printer, Stewart & Stewart

The process for screenprinting is more complex than the process used in making a stencil print. In screenprinting, artists can employ a variety of distinct techniques to create different kinds of images. The basic process involves stretching fabric tautly over an open frame support. The mesh fabric is tightly woven, so that ink won't flow through it without applied pressure. The stencil is then affixed to the screen by either attaching it to the frame with tape or adhering it as a film. Alternately, a glue-like substance is applied to form the stencil directly on the mesh. In either method, only the areas of the screen that are not occluded by the stencil will print.

The printer then places thick water-based or oil-based ink at one end of the frame and uses a squeegee or brush to press the ink through the open areas of the mesh and onto the paper, which is positioned beneath the screen on a flat, hard surface. Due to the technique's bold graphic characteristics, both artists and industrial designers often use it to create images rich in color. For these images, a separate screen is usually made for each color; the print is created as stencils are printed one over the other. Following this same procedure, an image can also be developed using transparent colors to create a wide range of hues and surface textures.

For many artists, screenprinting is more accessible than other printmaking processes. It's a simple technique that does not require a press. It can be executed on many different kinds of material and is well adapted to producing large-scale prints. Possibly the most important advantage of this technique for artists is the potential for printing in multiple colors. As the medium lends itself so well to opaque surfaces and imagery, the ink's tonal value and color are predictable; both are more consistent and accurate with screenprinting than with the other major printing processes. Overall, screenprints can display an impressive range of visual effects, from flat two-dimensional designs to intricately developed spatial fields of color.

©1999 www.StewartStewart.com

ARTIST: Susan Crile
TITLE: Assisi Reassembled
DATE: 1999
MEDIUM: Two-color screenprint
PAPER SIZE: 41 x 28½ inches
EDITION: 21
PUBLISHER: Stewart & Stewart

"Assisi Reassembled was Susan Crile's successful attempt to meet the challenge of creating a black-and-white version of the full-color Assisi screenprint by printing with only two inks: black and a translucent gray. Where the translucent gray was printed on the white paper it appears as a light gray. Where the translucent gray was printed over the black it appears as a dark gray. In total, we perceive four colors: the white of the paper, black, dark gray and light gray."
– Norm Stewart, partner and master printer, Stewart & Stewart

ARTIST: Hunt Slonem
DATE: 2000
PAPER SIZE: 28$\frac{1}{2}$ x 41 inches (each)
PUBLISHER: Stewart & Stewart

Above
TITLE: Finches Black
MEDIUM: Eight-color screenprint
EDITION: 31

Below
TITLE: Finches Red
MEDIUM: Seven-color screenprint
EDITION: 32

"The *Finches* series by Hunt Slonem is a wonderful example of inventive manipulation of the individual printing elements shared by editions in the series. *Finches Black* shares all the colors that are used in the *Finches Red* edition, with the substitution of black for the background color. Like many artists, Hunt Slonem enjoys seeing the results of placing similar or identical visual elements against different backgrounds."
— Norm Stewart, partner and master printer, Stewart & Stewart

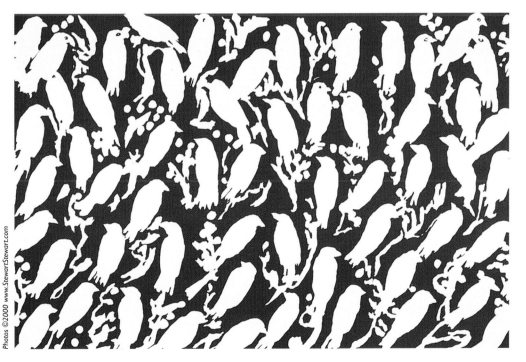

Photos ©2000 www.StewartStewart.com

ARTIST: Hunt Slonem
DATE: 2000
PAPER SIZE: 28¹/₂ x 41 inches (each)
PUBLISHER: Stewart & Stewart

Above
TITLE: Finches Ground Red
MEDIUM: One-color screenprint
EDITION: 20

Below
TITLE: Finches Ground Black
MEDIUM: One-color screenprint
EDITION: 24

"Occasionally an individual element used to create a screenprint edition has the visual strength to stand on its own. This is the case with *Finches Ground Red* and *Finches Ground Black*. The strong positive/negative pattern created by the finches against the respective backgrounds of red and black yield simple yet compelling images."
— Norm Stewart, partner and master
 printer, Stewart & Stewart

Photos ©1988 www.StewartStewart.com

ARTIST: Jane E. Goldman
PUBLISHER: Stewart & Stewart

Left
TITLE: Sun Porch
DATE: 1988
MEDIUM: 29-color screenprint
PAPER SIZE: 29¹/₂ x 21¹/₂ inches
EDITION: 60

Right
TITLE: Ellen's Window
DATE: 1990
MEDIUM: 20-color screenprint
PAPER SIZE: 29¹/₂ x 21 inches
EDITION: 64

Facing page
TITLE: Mid-Summer Light
DATE: 1987
MEDIUM: 28-color screenprint
PAPER SIZE: 21¹/₂ x 29¹/₂ inches
EDITION: 66

"Jane Goldman is a master of blending transparent inks and modulated imagery in screenprinting; *Sun Porch* is evidence of this. Here Goldman plays with reflective light from – and through – the glass tabletop. *Ellen's Window* reveals an interior view of objects on a neighbor's windowsill. Two of Goldman's signature elements are seen here: a glass surface and an unusually high viewer perspective. Of particular note is the incredibly beautiful handling of the floral imagery on the book, which appears below the bowls. Most noticeable in *Mid-Summer Light* is Goldman's penchant for placing the viewer at a high vantage point, looking down onto the pictorial space. The strong diagonals formed by the window elements punctuate this atypical perspective."

– Norm Stewart, partner and master printer, Stewart & Stewart

ARTIST: Ann Mikolowski
TITLE: Monhegan Island
DATE: 1995
MEDIUM: 17-color screenprint
PAPER SIZE: 41 x 28½ inches
EDITION: 32
PUBLISHER: Stewart & Stewart

"One of the most challenging effects
to render in screenprinting is a gradual
change from one color to another. In
Monhegan Island, Ann Mikolowski wanted
to re-create her memories of an ocean
mist as it approached the rocky coast
of this famous land mass off the coast
of Maine. The transition was successfully
achieved by using more than a dozen
thin veils of transparent inks and highly
modulated imagery."

 – Norm Stewart, partner and master
 printer, Stewart & Stewart

ARTIST: Martha Diamond
TITLE: Air
DATE: 1996
MEDIUM: Four-color screenprint
PAPER SIZE: 41 x 28¹/₂ inches
EDITION: 39
PUBLISHER: Stewart & Stewart

"Often labeled a neoexpressionist painter, Diamond is best known for cityscape abstractions in large, sweeping, gestural brush strokes. New York City is both her home and her dominant art theme. Influenced by Japanese prints, Diamond often translates her work into print media. In *Air*, buildings float on a sky of ethereal blue marks, moving the light diagonally."

— Norm Stewart, partner and master printer, Stewart & Stewart

Photo © 1997 www.StewartStewart.com

ARTIST: Ann Mikolowski
TITLE: Chairs
DATE: 1997
MEDIUM: One-color screenprint
PAPER SIZE: 21³/₄ x 29³/₄ inches
EDITION: 33
PUBLISHER: Stewart & Stewart

"Noted for her American marine paintings and miniature portraits, Mikolowski was inspired by a row of Adirondack chairs bordering the formal gardens of a grand old hotel in St. Andrews, New Brunswick, Canada. A chilly, rainy July afternoon discouraged people from sitting and instead resulted in a curious arrangement of empty chairs facing a manicured hedge. *Chairs* was drawn using the stipple technique (a process by which a design is composed of groups of dots rather than lines), then screenprinted in black ink."

— Norm Stewart, partner and master printer, Stewart & Stewart

ARTIST: Sondra Freckelton
TITLE: Cut Flowers
DATE: 1995
MEDIUM: One-color screenprint
PAPER SIZE: 21³/₄ x 29³/₄ inches
EDITION: 42
PUBLISHER: Stewart & Stewart

"Sondra Freckelton relies heavily on an accurate line drawing to plan the various layers of inks required to fully render her screenprint images in color. Because her line drawings are so beautiful, we decided to create a screenprint that focuses exclusively on line. *Cut Flowers* is the result of that successful focus."

— Norm Stewart, partner and master printer, Stewart & Stewart

ARTIST: Martha Diamond

TITLE: Towers

DATE: 1996

MEDIUM: One-color screenprint

PAPER SIZE: 41 x 28 $^{1}/_{2}$ inches

EDITION: 21

PUBLISHER: Stewart & Stewart

"In *Towers*, the repetitive patterns
of the architecture create a sense
of rhythm. The viewer's eye and mind
can respond to the monumentality
of these structures."

— Norm Stewart, partner and master
 printer, Stewart & Stewart

ARTIST: Martha Diamond
TITLE: Vignettes
DATE: 1996
MEDIUM: One-color screenprint
PAPER SIZE: 41 x 28 1/2 inches
EDITION: 21
PUBLISHER: Stewart & Stewart

"Vignettes, at first glance, seems to diverge from Diamond's usual focus on man-made structures. However, the images are derived from specific rooftops in New York City. With the exception of the man taking photographs, all images are of carvings of birds, cherubs and figurative sculptures. Diamond's renewed interest in drawing led her to extend her imagery to figurative architectural elements and to use them in her fine prints and paintings."

— Norm Stewart, partner and master printer, Stewart & Stewart

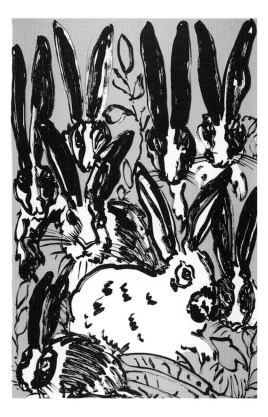

ARTIST: Hunt Slonem
PAPER SIZE: 41 x 28¹/₂ (each)
PUBLISHER: Stewart & Stewart

Top left and right
TITLE: Lucky Charm 2 B/W
DATE: 1997
MEDIUM: One-color screenprint
EDITION: 10

TITLE: Lucky Charm 2
DATE: 1997
MEDIUM: Three-color screenprint
EDITION: 25

Bottom left and right
TITLE: Lucky Charm B/W
DATE: 1997
MEDIUM: One-color screenprint
EDITION: 10

TITLE: Lucky Charm
DATE: 1997
MEDIUM: Three-color screenprint
EDITION: 25

"Like many of Hunt Slonem's screen-prints, the *Lucky Charm 2* B/W edition is based on a single ink drawing cre-ated by the artist, then screenprinted in black ink. This image is the base image for the screenprint *Lucky Charm 2*. As with *Lucky Charm 2*, the *Lucky Charm* edition started as a powerful and convincing ink drawing screenprinted in black ink. The addi-tional two printings added spot color to the image."
— Norm Stewart, partner and master printer, Stewart & Stewart

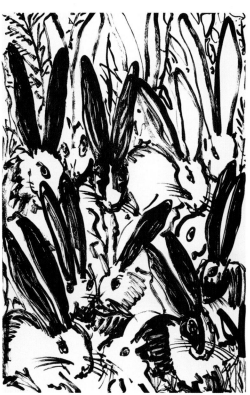
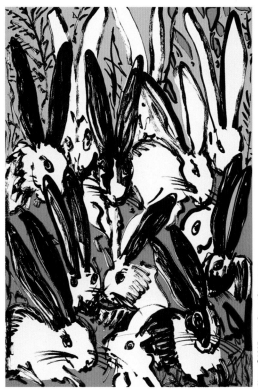

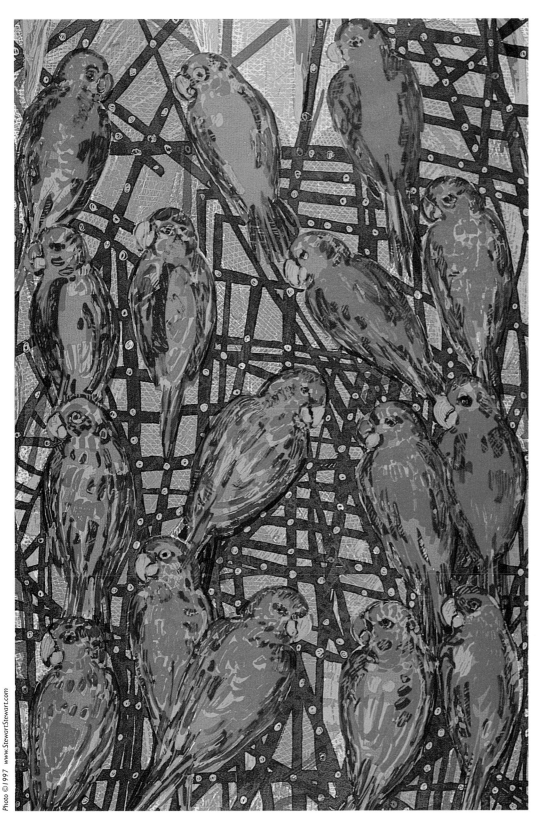

ARTIST: Hunt Slonem
TITLE: Lories
DATE: 1994
MEDIUM: Eight-color screenprint
PAPER SIZE: 41 x 28 1/2
EDITION: 47
PUBLISHER: Stewart & Stewart

"*Lories* was one of the three screen-prints Hunt Slonem completed during his first residency at Stewart & Stewart. This work most closely illustrates the legendary aviary of exotic birds Hunt maintains in one of his studios in New York City. The theme combines the birds and the elements used in the construction of the aviary awash in an intense red ink."
 – Norm Stewart, partner and master
 printer, Stewart & Stewart

ARTIST: Jane E. Goldman
PUBLISHER: Stewart & Stewart

Above
TITLE: Yellow Bittersweet
DATE: 1998
MEDIUM: 11-color screenprint
PAPER SIZE: 28¹/₂ x 41
EDITION: 65

Facing page
TITLE: Sumac on Glass
DATE: 1997
MEDIUM: 13-color screenprint
PAPER SIZE: 34 x 28¹/₂
EDITION: 64

"An interior view of a vase of yellow bittersweet and its ghostlike shadow on the wall in the artist's studio/residence is the subject for *Yellow Bittersweet*. This is the tenth screenprint Goldman completed at Stewart & Stewart and her first large print. The glass table featured in *Sumac on Glass* is one of Jane Goldman's favorite visual props. It is also featured in *Yellow Bittersweet*, which was completed a year later."

– Norm Stewart, partner and master printer, Stewart & Stewart

ARTIST: Sondra Freckelton
TITLE: Keeping Autumn
DATE: 1991
MEDIUM: 19-color screenprint
PAPER SIZE: 41 x 28¹/₂
EDITION: 42
PUBLISHER: Stewart & Stewart

"*Keeping Autumn* is Sondra Freckelton's seventh screenprint completed at Stewart & Stewart and her first large print. Her command of image development in screenprinting is a result of her extensive experience in watercolor painting. She created *Keeping Autumn* as she would have created it in watercolor."

— Norm Stewart, partner and master printer, Stewart & Stewart

ARTIST: Sondra Freckelton
TITLE: Souvenir
DATE: 1989
MEDIUM: 18-color screenprint
PAPER SIZE: 22 x 29³/₄
EDITION: 61
PUBLISHER: Stewart & Stewart

"As with many of Sondra Freckelton's screenprints, the props she selects for her still lifes have special meaning to her. The corn platter in the center of *Souvenir* was one of the many objects neighbors around her Oneonta, New York, farm left at her studio. It is their hope to occasionally see one of their special 'offerings' appear in her paintings or screenprints. The fabrics used in the background were found in various country flea markets."

— Norm Stewart, partner and master printer, Stewart & Stewart

CONTRIBUTING PUBLISHERS

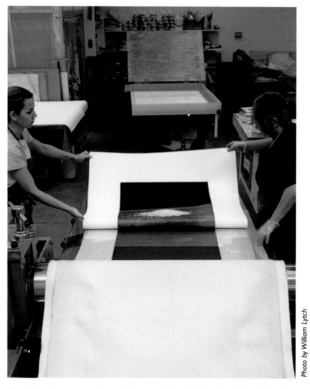

Graphicstudio master printers Jill Lerner (left) and Erika Greenberg-Schneider pull Liset Castillo's photogravure, *Rice*.

Photo by William Lytch

The following master printers and print publishers have made significant contributions to the field of contemporary fine art prints and have participated generously in the making of this book.

DERRIERE L'ETOILE STUDIOS

Derriere L'Etoile Studios was founded in 1976, when, after a long and varied education and apprenticeship in print-making, Maurice Sanchez bought his own press and began working with well-known artists. "Derriere L'Etoile" means "behind the star." Through the studio's use of inventive collaborations and techniques, it has been recognized as one of the premier print studios for artists in Manhattan.

FLATBED PRESS AND GALLERY

Flatbed Press was founded by Katherine Brimberry and Mark L. Smith in 1989. Located in Flatbed World Headquarters, an 18,000-square-foot warehouse, it was redeveloped in 1999 as a community of creative professionals. The facility, on Boggy Creek in Austin, Texas, includes the print shop, offices, galleries, a recital hall and a photography studio. This mix of the visual and performing arts provides a constant creative energy in the building. Flatbed collaborates with contemporary artists to publish etchings, lithographs and woodcuts.

GRAPHICSTUDIO/THE INSTITUTE FOR RESEARCH IN ART

The principal mission of Graphicstudio is to conduct research in art-making aesthetics and technology through collaborative projects with leading contemporary artists. Since its founding in 1968, more than sixty artists have worked with the studio to create print and sculpture multiples.

In the 1970s, Deli Sacilotto, Graphicstudio research director, was instrumental in reviving photogravure, an etching process that creates photographic prints with rich, velvety tonal values and surfaces. Through its research with artists such as Robert Mapplethorpe, Chuck Close and Edward Ruscha, Graphicstudio has led the way in the revitalization of this technique for use by contemporary artists.

PAULSON PRESS

Co-owners and master printers Pam Paulson and Renee Bott established Paulson Press as a publisher of intaglio prints in Berkeley, California, in 1996. While committed to talented artists of the San Francisco Bay area, Paulson Press also focuses on collaborating with nationally and internationally recognized artists who bring artistic excellence to the print medium. In 2001, the San Jose Museum of Art honored Paulson Press with a retrospective exhibition of its first five years. Art Prints from Paulson Press are included in the permanent collections of major museums, including the Metropolitan Museum of Art, the Whitney Museum of American Art, the Brooklyn Museum of Art and the San Francisco Museum of Art.

SEGURA PUBLISHING COMPANY, INC.

Founded by master printer Joseph Segura in 1981, Segura Publishing Company provides a collaborative environment for artists. Joe Segura's encyclopedic knowledge of printing processes has allowed his studio to develop innovative fine art prints, combining techniques both classic and contemporary.

SHARK'S INK

Shark's Ink was founded in 1976 by master printer Bud Shark. Bud's position as both publisher and master printer

Photo by William Lytch

Research director Deli Sacilotto etches a photogravure plate at Graphicstudio.

enables him to participate in every aspect of the creation of the print, from the selection of artists to the development of the image. Through ongoing relationships with a diverse group of artists, Shark's Ink has developed an innovative approach to producing contemporary prints.

STEWART & STEWART

Stewart & Stewart's print shop and artist's residence are set in the gardeners' quarters of the historical Book family summer estate (once owned by Edsel Ford) in Bloomfield Hills, Michigan. Since 1980, Stewart & Stewart has been recognized for its skillful use of transparent inks to create fine screenprints in collaboration with gifted American artists. In 1991, an exhibition dedicated to the first decade of the studio's work debuted at the Detroit Institute of Arts and traveled to eight other venues across the United States.

TAMARIND INSTITUTE

Tamarind Institute was founded as Tamarind Lithography Workshop in Los Angeles in 1960 with the full support of the Ford Foundation. Founding director June Wayne, along with associate director Clinton Adams and technical director Garo Antreasian, initiated multifaceted technical training, as well as educational and artistic programs designed to rescue lithography and transform it into a vital contemporary art form. When it moved to Albuquerque, New Mexico, in 1970, Tamarind Lithography Workshop became Tamarind Institute, a division of the College of Fine Arts at the University of New Mexico. Tamarind continues to train master printers, conduct research and encourage artists to use the medium creatively.

TANDEM PRESS

In 1987, the Department of Art at the University of Wisconsin—Madison founded Tandem Press, a workshop providing an interdisciplinary approach to the visual arts. Located in a state-of-the-art facility, Tandem's studio creates an environment dedicated to research and experimentation in printmaking. It has ongoing relationships with many leading international artists.

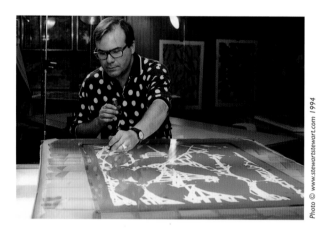

Photo © www.stewartstewart.com 1994

Hunt Slonem makes image adjustments to his screenprint *Lories*, at Stewart & Stewart.

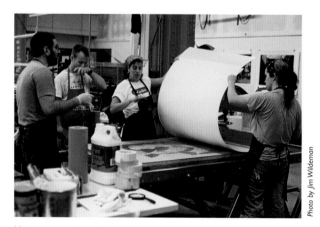

Photo by Jim Wildeman

Master printer Andrew Rubin and assistants proof a lithograph at Tandem Press.

CONTRIBUTING ARTISTS

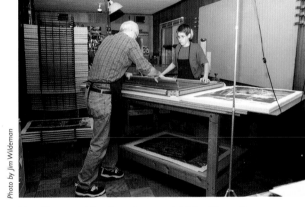

Photo by Jim Wildeman

Norm Stewart and Sean Stewart screenprint *Yellow Bittersweet* by Jane E. Goldman.

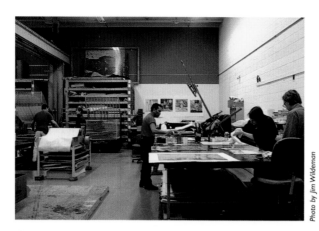

Photo by Jim Wildeman

Gronk works with assistants to develop monoprints at Tandem Press.

David Row
Page 99

Juan Sánchez
Pages 84, 94

Italo Scanga
Page 95

Bob Schneider
Page 41

Hollis Sigler
Page 23

Hunt Slonem
Pages 106-107, 116-117

Mary Snowden
Pages 92-93

Art Spiegelman
Pages 78, 90-91

James Surls
Pages 29, 39, 70

James Turrell
Pages 42, 48-49

Liz Ward
Page 51, 53

John Waters
Pages 2-3, 4

Stephanie Weber
Page 98

Emmi Whitehorse
Page 65

Betty Woodman
Page 17

Thomas Woodruff
Page 81